Presidential
CAMPAIGN
POSTERS

FROM THE

LIBRARY OF CONGRESS

LIBRARY OF CONGRESS

QUIRK BOOKS
PHILADELPHIA

Designed by Doogie Horner
Production management by John J. McGurk
Editorial contributions by Robert Schnakenberg

For the Library of Congress:
Director of Publishing: W. Ralph Eubanks
Project manager and image editor: Amy Pastan
Contributors: Ralph Eubanks, Aimee Hess, Jonathan Horowitz, Elizabeth McDonald, Linda Osborne, Amy Pastan, Susan Reyburn, Maria Snellings, Sarai Reed, David Trigaux, Margaret Wagner, and Tom Wiener

Special thanks to Jan Grenci in the Department of Prints and Photographs, Library of Congress, for providing access to the collections and for her other significant contributions to this project.

Additional thanks to Helena Zinkham, Barbara Natanson, and Kit Peterson in the Library of Congress Department of Prints and Photographs, the staff of the Library of Congress Duplication Services, Denise Gallo and Stephen Yusko of the Library of Congress Sheet Music Collection, Michelle Krowl in the Library of Congress Manuscript Division, Dodge Chrome, and Athena Angelos.

Quirk Books
215 Church Street
Philadelphia, PA 19106
quirkbooks.com
10 9 8 7 6 5 4 3 2 1

Contents

PREFACE

We media consumers are far too jaded by national politics to be influenced by campaign posters, *right*? We all know that posters are blatant manipulations, intended not to inform but to enlist. They emphasize faces and catchphrases. They condense complicated issues into jagged little pills. They are blunt instruments.

At the same time, the most effective campaign posters of every era leave as much as possible to the voter's imagination. They are like Japanese manga: the less detailed the image, the more easily we can identify with the candidate, the more space for projecting our dreams. The more specific the image, the greater the risk of creating a feeling of "otherness," which translates into death at the polls.

Consider the most celebrated example of campaign art in recent years: Shepard Fairey's Warhol-esque poster for Barack Obama's 2008 run for the White House. Uncluttered, with none of the little moles and stray hairs often depicted in nineteenth-century candidate etchings, it lacks even the presidential hopeful's name. It contains a message of the purest kind, in the form of a single word: *hope*.

This poster presented far more than a focused portrait of youth, strength, and sobriety (though it communicated all of those things, too). It managed the stunning feat of portraying a black presidential candidate while visually overcoming the "otherness" of being black in America. Fairey's inspired rendering of an evolved, postracial America turned otherness on its head. America saw this mythic image of itself and applauded. Like all great political art, the *Hope* poster did not merely brand a candidate; it branded America. It branded *us*.

And in fact, that is what campaign art really is selling. Fundamentally, it isn't pitching politicians; it's hawking images of America. The America we yearn for. Or, when the message is negative, the America we fear.

It's a truism that Americans cast their votes for candidates not on policy but on character. We vote for the person whom we want to be our public face for the next four years, the face the nation sees when it looks in the mirror. Consider just a handful of examples among, well, *every* winning candidate. Harry Truman, John F. Kennedy, Ronald Reagan,

and George W. Bush were not elected on their experience or qualifications, but on who they seemed to be.

"Give 'em Hell" Truman and the language-mangling Bush were portrayed as rough and ready regular guys, as opposed to their effete and supercilious opponents, John Dewey and Al Gore (and, later, John Kerry). Kennedy—whose slogan was "Leadership for the '60s"—was the heroic, handsome harbinger of an America bursting with vim and "vigah" running against Richard Nixon's stooped and sweaty status quo. Reagan's posters depicted optimism tempered by the wisdom of age. His campaign emphasized rebirth ("Bringing America Back!") while his opponent, Jimmy Carter, seemed steeped in a self-diagnosed malaise. Who wants to live in an America like that?

What is perhaps most striking about this collection of posters from the Library of Congress—our oldest federal cultural institution, and one that serves as America's memory—is what it reveals about the unchanging nature of American politicking. In the 1876 race between Republican Rutherford B. Hayes and Democrat Samuel Tilden, Tilden was dubbed "Slippery Sammy," barely a hairsbreadth from the Nixon epithet "Tricky Dick." These echoes are uncanny, considering that early campaign posters predated modern advertising, marketing, and branding, not to mention the now never-ending research into the psychology of primary colors, the semiotics of sans serif, and the syntactics of the sound bite.

In these posters, we see the same posturing, the same accusations (of corruption, of moral turpitude) and insinuations (of suspicious religious beliefs, of hidden affiliations) hurled across party lines through the centuries. We see in black-and-white and color that the incivility that modern Americans decry as symptomatic of a sick political system has, in fact, been with us always.

Consider the earliest campaign featured here: Andrew Jackson's 1828 race against incumbent president John Quincy Adams. Adams reached out to the electorate through the press, while the Jackson brain trust focused on the common man—who, in many cases, was illiterate—and handed out hickory brooms and canes denoting "Old Hickory" Jackson.

In response, Adams's supporters lashed out, accusing Jackson of atrocities in the War of 1812, but their efforts were to no avail. The common man carried Jackson to the White House.

Virtually every campaign finds candidates aligning themselves with the common man to win votes. It's the hardiest gambit of American politics, and sometimes the portrayal of a candidate as everyman even reflects reality. James Garfield, depicted on his 1880 poster as a farmer "cutting a swath to the White House" through "falsehood, malice, and fraud," truly had pulled himself out of poverty. But reality is beside the point.

A few years earlier, Ulysses S. Grant's 1872 campaign posters portrayed him, under the "Working-man's Banner," as a tanner and his running mate Henry Wilson as a shoemaker. Neither was either. In fact, Grant's campaign was financed by such wealthy American businessmen as Cornelius Vanderbilt, Jay Cooke, and John Astor. But hitching a ride on the back of the common man was the surest way for Grant to hold on to the White House, especially when running against the ultimate Eastern liberal elite, newspaper editor Horace Greeley.

Grant's posturing as a member of the working class was as blatant—and effective—as George W. Bush's cowboy bonhomie, pitched against the notion of John Kerry as a windsurfing liberal. Still, no single image or slogan wins an election. A candidate has to catch a wave and ride it to 1600 Pennsylvania Avenue. The posters and catchphrases contained here are like little skiffs navigating the currents of America's turbulent political waters.

The ultimate lesson of this collection is how choppy those waters are. Political art is nothing less than an illustration of the skirmishes and stalemates that created and continue to animate the American experiment. As you look at each poster and read about each campaign, it becomes increasingly clear that the tug of war over taxes and trade, the distribution of wealth and power, and the role of government itself, will never end.

Every generation renews the battle and fights it again. And every time, political candidates borrow from past campaigns the lexicon of perpetual political war. It reverberates in the slogans and the speeches, the *urgent* need:

for tax relief or social protections, for an active government or a dormant one, for war or peace, to stay the course or to change direction.

Among the slogans missing from this volume (which could not possibly contain them all) is one adopted by Democrat John Kerry during his unsuccessful run against George W. Bush in 2004: "Let America be America Again." It is the title of a 1938 poem by Langston Hughes, the celebrated poet of the Harlem Renaissance. Kerry focused on its first lines:

Let America be America again.
Let it be the dream it used to be.

But Hughes was being bitterly ironic. He knew that the American dream, if it meant freedom and justice for all, had never been a reality. And he suspected that perhaps, for the majority, it had never even been a dream.

(There's never been equality for me,
Nor freedom in this "homeland of the free.")

But however marginalized Hughes was, he nevertheless was fully engaged in the rhetoric of political battle. He took up the cudgels provided by the First Amendment and resolved to take no prisoners. That is how Americans are supposed to fight for their democracy. That no side can hold its ground forever is irrelevant.

America never was America to me,
And yet I swear this oath—
America will be!

We each carry a notion of an America that has never existed and can never exist. But we take our posters into the real streets anyway.

—BROOKE GLADSTONE

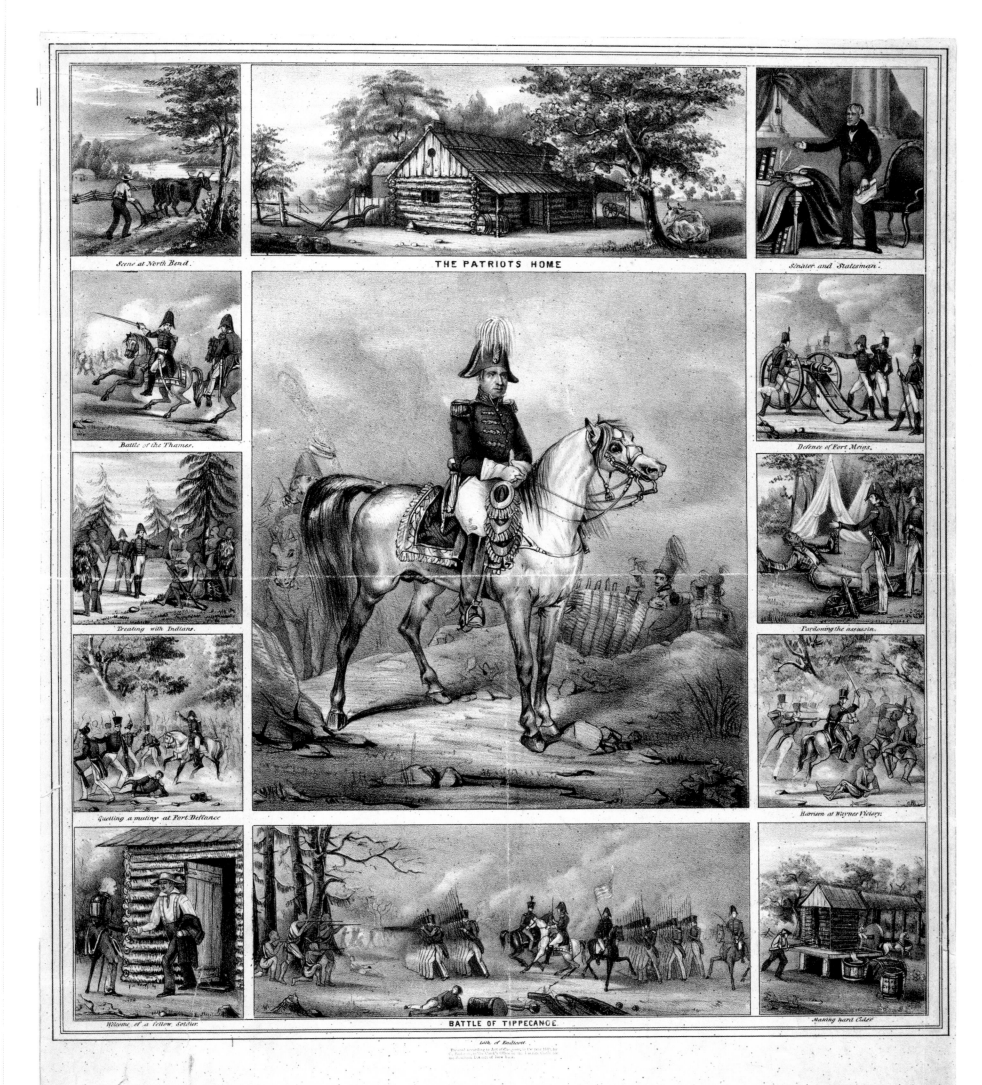

Scene at North Bend.

THE PATRIOTS HOME

Senator and Statesman.

Battle of the Thames.

Defence of Fort Meigs.

Treating with Indians.

Pardoning the assassin.

Quelling a mutiny at Fort Defiance

Harrison at Wayne's Victory.

Welcome of a fellow Soldier.

BATTLE OF TIPPECANOE.

Making hard Cider.

GEN. WILLIAM HENRY HARRISON

NEW YORK
Published by Endicott, 152, Fulton Street.

1840

William Henry Harrison (Whig) v. Martin Van Buren (Democrat)

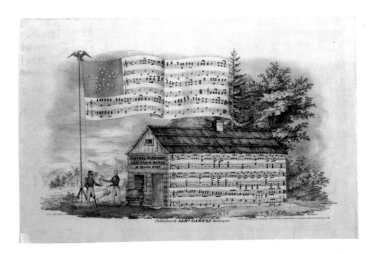

General Harrison's Log Cabin March & Quick Step, lithograph by Sam Carusi, 1840. Sprightly music accompanies this less-than-accurate depiction of Whig candidate William Henry Harrison as a log-cabin-dwelling cider drinker.

"Give him a barrel of hard cider and a pension of two thousand a year . . . and he will sit the remainder of his days in a log cabin."

—The Baltimore Republican *newspaper, making fun of the aging Harrison*

Electoral Votes	Popular Votes
Harrison 234	Harrison 1,275,390
Van Buren 60	Van Buren 1,128,854

What more could the American people want than a president who was both a military hero and a man of the people? That's how the Whig Party banked on winning the election of 1840, when they chose William Henry Harrison to run against incumbent Democratic president Martin Van Buren. Harrison may not have been the most distinguished general, but he had conquered American Indians at the Battle of Tippecanoe, in 1811, and helped defeat the British in the War of 1812. John Tyler was chosen as his running mate, and "Tippecanoe and Tyler, Too" became the duo's catchy campaign slogan.

The media-savvy Whigs adjusted a few key aspects of their candidate's image. Harrison was sixty-seven during his presidential campaign, but this poster depicts him in more youthful glory. It also shows him alongside a log-cabin home. In fact, Harrison had been born into a distinguished and well-off Virginia family and lived on a large, comfortable farm in Ohio. Nevertheless, he campaigned as the candidate of humble homes and hard cider (the working man's drink) while the Whigs worked hard to portray Martin Van Buren as the wine-tippling aristocrat who spent money on extravagances as Americans suffered through an economic depression.

Huge crowds gathered for Harrison rallies, where free hard cider (and sweet cider, for teetotalers) flowed plentifully. Women campaigned for him even though they couldn't vote, raising criticism from Van Buren's Democrats. Undaunted by the disapproval, women continued to give "lady toasts" and marched in parades carrying brooms to sweep Van Buren out of office. Whig supporters published log-cabin newspapers and songbooks, and log cabins sprang up in cities and towns across the country. Campaign souvenirs included Harrison and Tippecanoe handkerchiefs, shaving

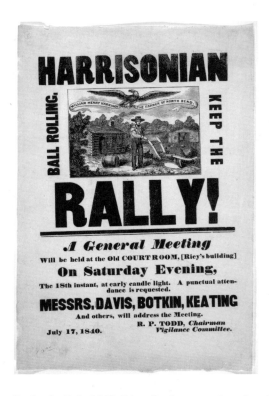

Harrisonian Rally, 1840. This notice for a general meeting of Harrison supporters features the popular slogan "Keep the Ball Rolling!"

cream, pitchers, coffee pots, and ribbons. E. C. Booz of Philadelphia even marketed "Old Cabin Whiskey" in cabin-shaped bottles; soon after, booze became another name for liquor. To "keep the ball rolling" for Harrison, Whigs plastered campaign slogans onto spheres as big as twelve feet in diameter and rolled them through villages and countrysides, calling out: "What has caused this great commotion, motion, motion / Our country through? / It is the ball a-rolling on / For Tippecanoe and Tyler, too." In the end, the Whigs succeeded, rolling Harrison straight into the White House.

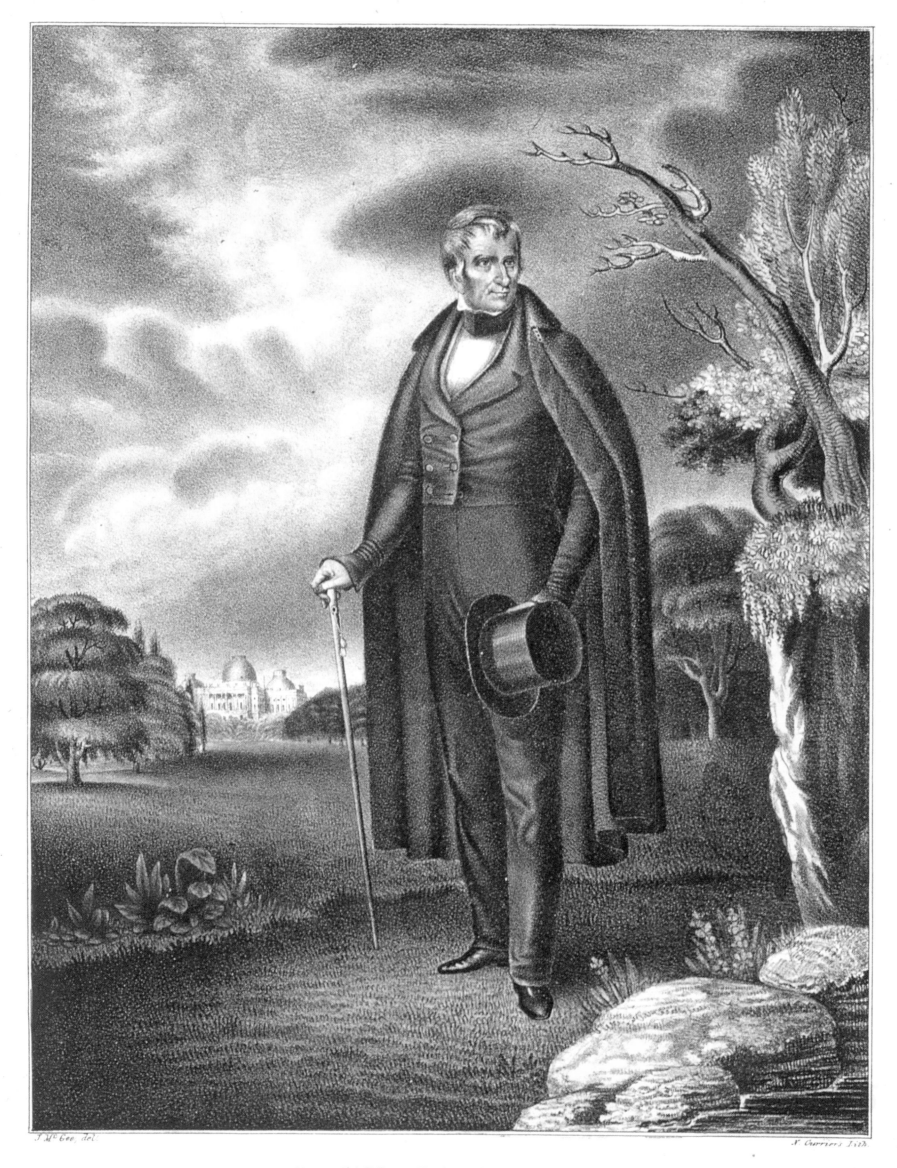

J. McGee, del. N. Currier's Lith.

WILLIAM HENRY HARRISON

Pub. by N. Currier 2 Spruce St N.Y.

1840

William Henry Harrison (Whig) v. Martin Van Buren (Democrat)

"Old Tip he wears a homespun coat
He has no ruffled shirt-wirt-wirt
But Mat he has the golden plate
And he's a little squirt-wirt-wirt."

—*Whig campaign chant*

Electoral Votes	Popular Votes
Harrison 234	Harrison 1,275,390
Van Buren 60	Van Buren 1,128,854

The distinguished gentleman in this portrait looks prosperous and presidential, but, in fact, William Henry Harrison campaigned as a man from humble roots when he ran against Democrat Martin Van Buren. Harrison's party, the Whigs, ignored his distinguished beginnings and college education and embraced common log cabins and hard cider as his campaign symbols. These are combined in this woodcut emblem, which was printed on banners and broadsheets for supporters to display.

Harrison was the first presidential candidate to hit the road on his own behalf, giving more than twenty speeches to the public. Advised when he ran for president in 1836 to "say not one single word about his principles or his creed," these orations were basically all talk, little substance. Opposing Democrats called him "General Mum" because he said nothing about financial policy, slavery, or other issues of the day. They accused the Whigs—the "ruffle-shirt, silk-stocking" upper class—of baiting a trap with free hard cider to lure "the industrious and laboring classes" into voting for Harrison against their own best interests.

But the Democrats' assertions did little to affect Harrison's popularity. Moreover, voters accepted exaggerated Whig criticism of rival candidate Martin Van Buren, during whose presidency the nation had plunged into economic depression. One congressman declared that Van Buren spent "his money [on] the purchase of rubies for his neck, diamond rings for his fingers, Brussels lace for his breast . . . Eau de Cologne, . . . [and] Corinthian Oil of Cream." Even Van Buren's supporter Andrew Jackson, twice president and a proven man of the people, was unable to convince voters to cast a ballot for him.

The cider-and-cabin campaign worked, and Harrison won the election. Once elected, however, the new president decided to project a different image from that of the hard-drinking commoner he had used to secure office. Instead, he presented himself as a well-educated statesman whose inaugural address was the longest in American history—almost two hours and with frequent references to Roman history. To show he was strong and healthy, the sixty-eight-year-old refused to wear a coat or hat while delivering his speech during a snowstorm. He caught a cold and died of pneumonia a month after taking office—becoming the first president to die on the job and holding the record for the shortest term.

Federal-Abolition-Whig Trap, woodcut, 1840. The basic message of this campaign broadside: Beware hard-working voters of Louisiana—Harrison's humble image is a trap to ensnare your votes!

Harrison and Tyler campaign emblem, woodcut, 1840. Probably intended for use on broadsides and banners, the emblem bolsters the shirtsleeve-sporting Harrison's appeal to the common man.

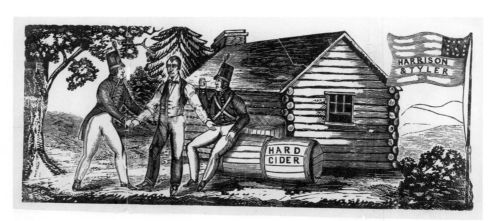

ORIGINAL PICTORIAL
ROUGH AND READY MELODIES,
No. 3.

T. HORTON DEL.

UNCLE SAM.—You look very pretty, Mr. Gass, but you can't come in; I've had so many of your sort already that I hardly know my own farm.

OLD ZACK TAYLOR IS THE MAN!

TUNE—"*Yankee Doodle.*"

Old ZACK TAYLOR is the man,
 His countrymen select him,
To fill the chair of Washington;
 And surely they'll elect him.

Chorus—Old ZACK TAYLOR! keep him up!
 Honest, Rough and Ready!
 We've a voucher in his life
 He's good as he is steady.

When Uncle Sam last let his farm,
 Right sorry soon he'd done it,
He saw them knock his fences down,
 And *poke*-weeds overrun it.
Chorus—Old ZACK TAYLOR! keep him up, &c.

But once again in careful hands,
 The right sort will be growing;
As Uncle Sam found out one day,
 A Taylor apt at *sow*-ing.

Chorus—Old ZACK TAYLOR, &c.

The politicians now must learn
 'Tis not for them to reap all;
Though *they* may mark out party lines,
 We've none for the whole people.

Chorus—Old ZACK TAYLOR is the man, &c.

Polk thought when first the war began
 How grand *he'd* be in story!
He little dream'd how Zack would rise,
 And carry off the glory.
Chorus—Old ZACK TAYLOR, &c.

In politics' mysterious ways
 Good often comes from evil;
So Polk's ascendancy has brought
 His party to the ——— !
Chorus—Old ZACK TAYLOR, &c.

In ZACK we know we've chosen well—
 The noble, the undaunted—
One who's "no private ends to serve,"
 Is one we long have wanted.
Chorus—Old ZACK TAYLOR, &c.

Good cheer to every patriot's heart—
 The field is to the trusty—
"When thieves fall out, then honest men"—
 The proverb's old and musty.
Chorus—Old ZACK TAYLOR, &c.

So gassy Cass, why you must pass—
 You shifting, sly pretender—
We've tried the tricksters long enough—
 We'll try our flag's defender.
Chorus—Old ZACK TAYLOR, &c.

NEW-YORK: Published by Horton & Co. Engravers and Publishers, 60 Nassau Street.
Entered according to Act of Congress, in the year 1848, by T. Horton, in the Clerk's Office of the District Court of the United States for the Southern District of New-York.

328.

Deposited in Clerks Office So. Dist. Miss. July 13. 185

1848

Zachary Taylor (Whig) v. Lewis Cass (Democrat) v. Martin Van Buren (Free Soil)

"Give them a little more grape, Capt. Bragg."

—*Zachary Taylor*

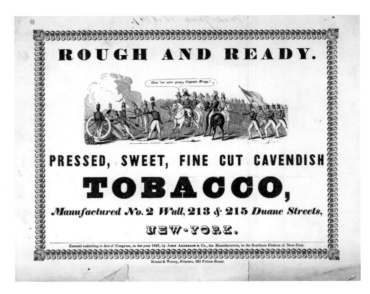

Rough and Ready, print, c. 1847. This tobacco ad depicts Taylor's big moment at the battle of Buena Vista.

Electoral Votes	Popular Votes
Taylor 163	Taylor 1,361,393
Cass 127	Cass 1,223,460
Van Buren 0	Van Buren 291,501

There's something timeless about the title of Zachary Taylor's campaign song, as emblazoned across this poster: "Old Zack Taylor Is the Man!" It sounds like something a twenty-year-old fraternity brother might shout about a revered upperclassman—which, when you get down to it, isn't a bad analogy for Taylor's situation. When the Whigs nominated him for president, he was a forty-year army veteran who had never run for office. His lack of political experience didn't faze the Whigs; they had pulled off the same maneuver with William Henry Harrison eight years earlier. Taylor's lack of political bona fides—and opinions—allowed his supporters to apply to him any convenient position they wished. If the Democrats were identified with one cause, then, by gum, Old Rough and Ready Zack Taylor stood against it.

News of Taylor's service to his country came just in time for those looking for a candidate to supplant President James Polk, initiator of the increasingly unpopular war with Mexico. In 1847, while Taylor led troops at the battle of Buena Vista, he rode over to an artillery position commanded by Capt. Braxton Bragg, asking what sort of shot was being used. Single shot, came the reply. Taylor said, "Double-shot your guns and give them hell, Bragg." When the Mexicans withdrew with significant losses, Taylor was hailed a hero, and, in subsequent popular retellings of the battle, his order to Bragg would evolve into the more succinctly poetic, "Give them a little more grape, Capt. Bragg."

Taylor cut quite the figure on the battlefield—outfitted in his uniform and seated astride his beloved horse "Old Whitey"—though more often he was dressed informally, sporting a tattered straw hat perched atop his head. Democrats seized on these descriptions to declare him too stingy to buy nice clothes; other criticisms leveled against him included his ownership of slaves and

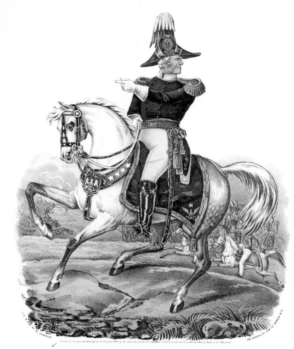

Major General Zachary Taylor: Rough and Ready, hand-colored lithograph published by Nathaniel Currier, 1847. This heroic poster includes, in small print, the boast that Taylor never lost a battle, a precedent upheld by his 1848 election victory.

greedy overdraws of military pay from Washington.

Nevertheless, Taylor won the election, thanks in part to the candidacy of former president Martin Van Buren, whose antislavery Free Soil Party siphoned enough Democratic support in New York to swing its major block of electoral votes to the Whigs. Despite his Louisiana residency and history of slave holdings, Taylor split the south with Democrat Lewis Cass. It made no difference—old Zack Taylor was the man.

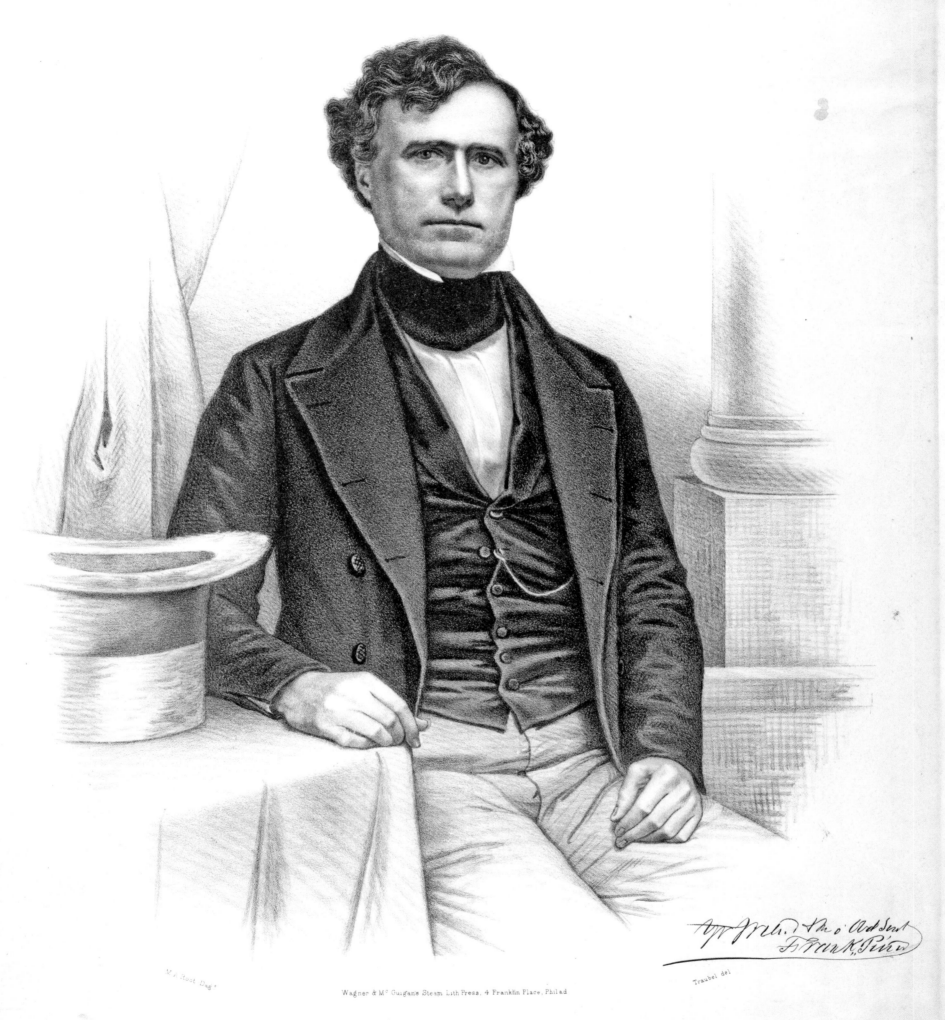

M. A. Root Dag.

Wagner & Mc. Guigans Steam Lith Press, 4 Franklin Place, Philad

Traubel del.

GENL. FRANKLIN PIERCE,

Democratic Candidate for the Presidency.

From a Daguerreotype of M. A. Root, 140 Chesnut St. Philada.

Pubd by Wagner & McGuigan, 4 Franklin Place, Philad

Entered according to an act of Congress in the year 1852, by Wagner & McGuigan, in the Clerk Office of the District court of the eastern District of Pennsyla

1852

Franklin Pierce (Democrat) v. Winfield Scott (Whig)

"You are looking at the most surprised man who ever lived!"

—*Franklin Pierce*

Electoral Votes	Popular Votes
Pierce 254	Pierce 1,607,510
Scott 42	Scott 1,386,942

The lowest voter turnout in twenty years pretty much said it all about the lackluster candidates in the 1852 presidential race. The Whigs nominated a hero of the Mexican War, Gen. Winfield Scott, hoping to repeat the successes of war heroes in the elections of 1840 (William Henry Harrison) and 1848 (Zachary Taylor). But Scott didn't wield the same tough street cred his brothers-in-arms had boasted; his nickname, "Old Fuss and Feathers," suggests right off the bat that this military man, who favored fancy uniforms and the theatrics of the parade ground, was more style than substance. It took fifty-three ballots at the Whig national convention before Scott secured the nomination; Democrats promptly called him "weak, conceited, and foolish" and held his lifelong career in the armed services against him.

The Democratic candidate, Franklin Pierce, could also claim a Mexican War record, but only as an enlisted officer. A former New Hampshire senator with a modest record of achievement, Pierce wasn't expecting to win the nomination, and indeed the Democrats needed forty-nine ballots to settle his candidacy—hardly a greater mandate than Scott's. On the campaign trail, Pierce found himself attacked for having passed out on the battlefield. Dubbed "The Fainting General," he turned to old college chum Nathaniel Hawthorne to pen a campaign biography that would set the record in his favor. Hawthorne's account of Pierce's life left out the candidate's predilection for distilled spirits, which was known nonetheless and provided cartoonists with plenty of material.

The public's already low enthusiasm for the election was further dampened when both parties came out in favor of the Compromise of 1850, an attempt by Congress to allay tensions over the expansion of slavery into new states and territories. It was one of several such legislative compromises that would serve only to delay the inevitable clash between free and slave states, satisfying no one along the way. In the end, the 1852 election marked the swan song for the Whig Party as a major political organization. The Democrats swept nearly every state, losing only four: Massachusetts, Vermont, Kentucky, and Tennessee.

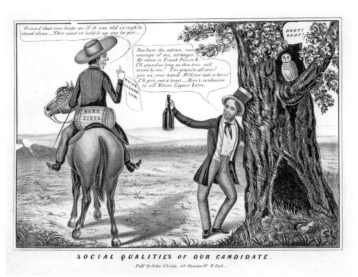

Social Qualities of Our Candidate, lithograph published by John Childs, 1852. Reports of alcoholism haunted Franklin Pierce during the campaign. In this cartoon, the inebriated candidate duels verbally with a supposedly abstemious Quaker, whose horse carries a keg of hard cider.

The Great Footrace for the Presidential Purse, lithograph published by Nathaniel Currier, 1852. This cartoon shows Daniel Webster vying with candidates Scott and Pierce for the chief executive's salary, which, over a four-year term, would amount to $100,000.

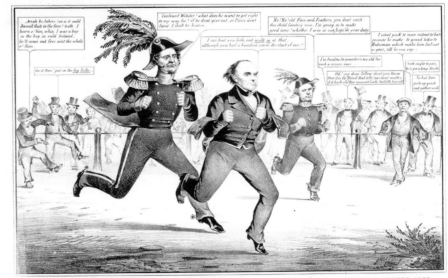

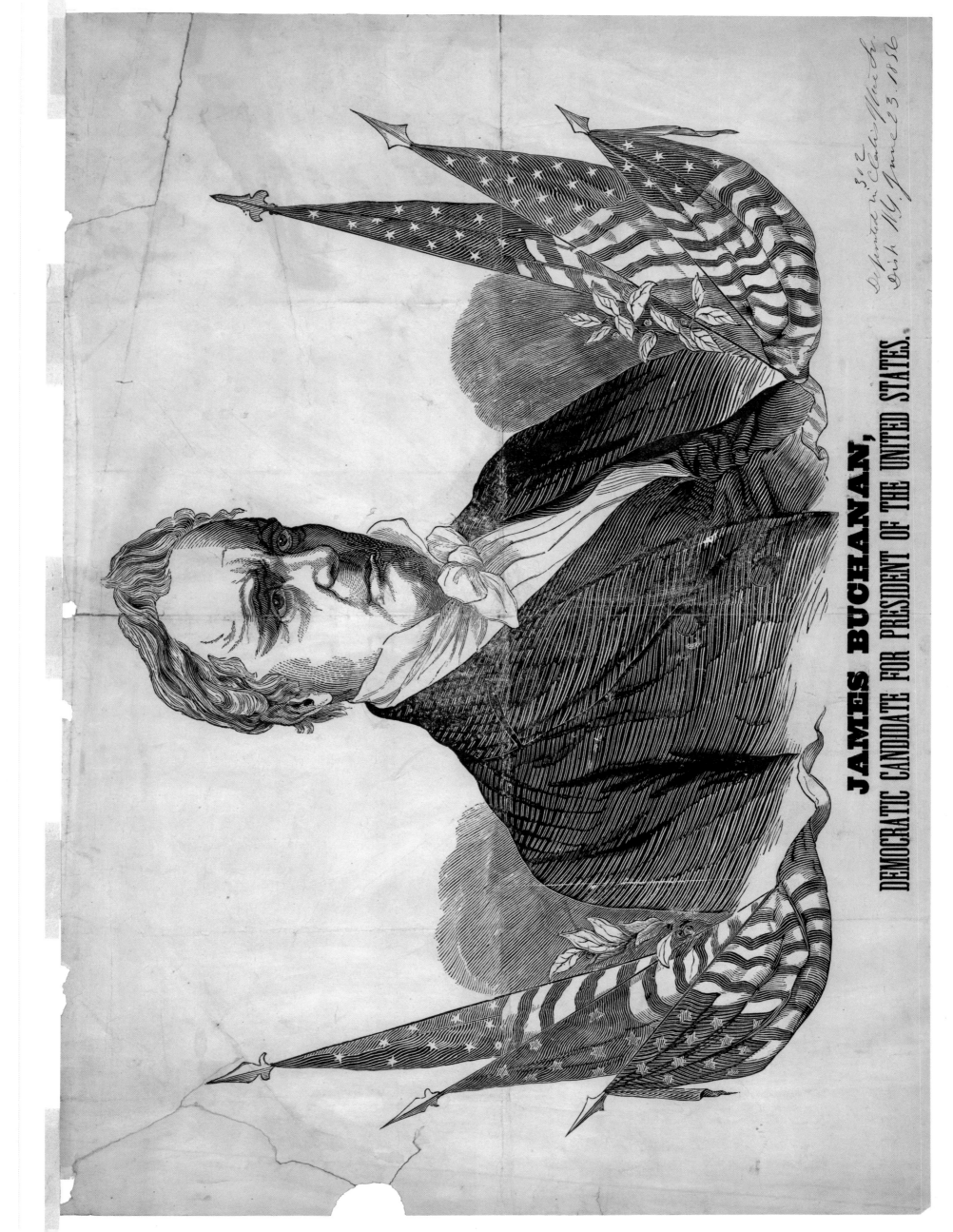

JAMES BUCHANAN,
DEMOCRATIC CANDIDATE FOR PRESIDENT OF THE UNITED STATES.

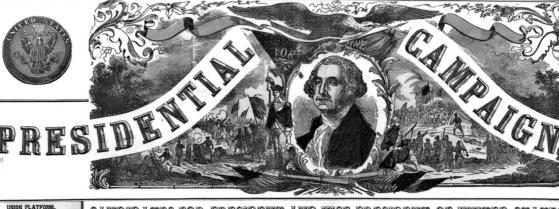

PRESIDENTIAL CAMPAIGN, 1864

ABRAHAM LINCOLN.

JOHN ADAMS.

JOHN QUINCY ADAMS.

GEO. BRINTON McCLELLAN.

CANDIDATES FOR PRESIDENT AND VICE-PRESIDENT OF UNITED STATES.
ELECTION, TUESDAY, NOVEMBER 8, 1864.

UNION PLATFORM.

DEMOCRATIC PLATFORM.

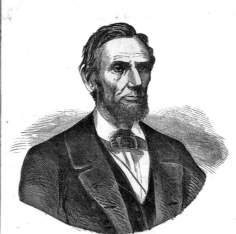

ABRAHAM LINCOLN,
OF ILLINOIS.

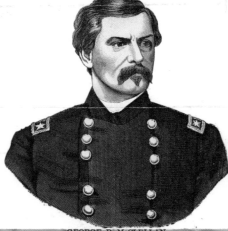

GEORGE B. McCLELLAN,
OF NEW JERSEY.

THOMAS JEFFERSON.

ANDREW JACKSON.

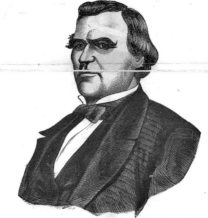

ANDREW JOHNSON,
OF TENNESSEE.

GEORGE H. PENDLETON,
OF OHIO.

McClellan's Letter of Acceptance.

ORANGE, N. J., Sept. 8, 1864.

JAMES MADISON.

ANDREW JOHNSON.

MARTIN VAN BUREN.

Lincoln's Letter of Acceptance.

MAP showing Loyal States in GREEN, what the Rebels still hold in RED, and what the Union Soldiers have wrested from them in YELLOW.

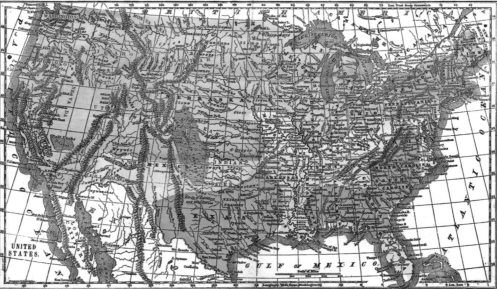

UNITED STATES.

GULF OF MEXICO.

Popular Vote for President.

JAMES MONROE.

W. H. HARRISON.

GEORGE H. PENDLETON.

SHRINKAGE OF THE REBELLION.

ELECTORAL COLLEGE.

Result of Presidential Elections in U. S. from 1796 to '60.

NATIONAL UNION EXECUTIVE COMMITTEE.

NATIONAL DEMOCRATIC EXECUTIVE COMMITTEE.

Date of Birth of Presidents of the United States.

JAMES K. POLK. **ZACHARY TAYLOR.**

MILLARD FILLMORE. **FRANKLIN PIERCE.**

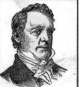

JAMES BUCHANAN.

JOHN TYLER.

Published by H. H. LLOYD & CO., 21 John Street, New York. B. B. RUSSELL, 515 Washington Street, Boston. R. R. LANDON, 88 Lake Street, Chicago. Agents wanted to sell this and many other New and Popular Works.

1864

Abraham Lincoln (Republican) v. George B. McClellan (Democrat)

"In a crisis of the most appalling magnitude requiring statesmanship of the highest order, the country is asked to consider the claims of two ignorant, boorish, third-rate backwoods lawyers for the highest stations in the Government. Such nominations, in such a conjuncture, are an insult to the common sense of the people. God save the Republic!"

—*Commentary by the* New York World *on the Lincoln–Johnson ticket, 1864*

Electoral Votes	Popular Votes
Lincoln 212	Lincoln 2,218,388
McClellan 21	McClellan 1,812,807

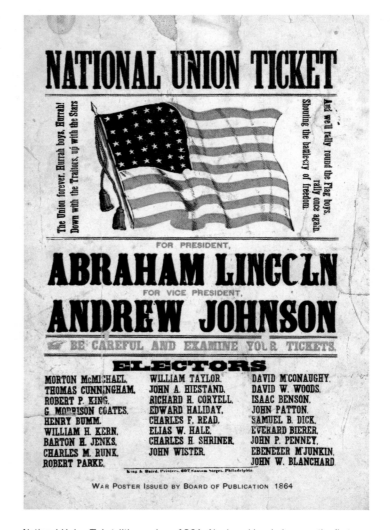

National Union Ticket, lithograph, c. 1864. Abraham Lincoln became the first president since Andrew Jackson in 1832 to win reelection.

Flanked by historical figures and the platforms of the two contending parties, the portraits of Abraham Lincoln, George B. McClellan, and their respective running mates loom over a map of a divided United States. Showing Union areas in blue, Confederate areas in red, and areas wrested from rebel control by Union armies in yellow, the map is a graphic reminder of the devastating three-year-old Civil War, which entered a bloody new phase in spring of the 1864 election year.

Union casualties for 1864 alone mounted into the tens of thousands as Gen. Ulysses S. Grant's drive toward the Confederate capital of Richmond devolved into a battle-punctuated siege, and Maj. Gen. William T. Sherman's army made slow progress toward the Confederate city of Atlanta. Off the battlefield, war weariness, conflicting aims, and personal vendettas and ambitions created a volatile political atmosphere. After Lincoln overcame an attempt by some dissatisfied souls within the Republican Party to remove him from the 1864 ticket, the party assembled in Baltimore. They called their meeting the National Union convention in an effort to attract not only fellow Republicans but also so-called War Democrats, who, unlike their Peace Democrat brethren, supported the military drive to bring the Confederate states back into the Union.

Regardless of their personal opinion of Lincoln, some War Democrats supported the Lincoln–Johnson National Union ticket; others remained with their party, whose strategists were convinced that, with popular general George B. McClellan as their candidate, they could win the White House and end the war. Whether a McClellan administration would truly insist on peace terms to preserve the Union or allow the Confederacy to go its own way remained open to question. And it was a question that would remain forever unanswered. As McClellan prepared to accept his nomination, Sherman took Atlanta, and, in the weeks thereafter, Gen. Phil Sheridan's Union forces won a series of morale-boosting victories in Virginia. In November, at the end of a rancorous campaign, *Harper's Weekly* printed an elongated portrait of the six-foot-four president, next to which it reported that the country had voted to keep "Long Abraham Lincoln, A Little Longer."

REPUBLICAN CHART.

PRESIDENTIAL CAMPAIGN, 1868.

Sketch of the Life of GEN. ULYSSES S. GRANT.

Sketch of the Life of HON. SCHUYLER COLFAX.

BATTLE OF THE WILDERNESS.

GRANT, IN PEACE.

GRANT & COLFAX

FOR PRESIDENT AND VICE-PRESIDENT,

ON THE FOLLOWING PLATFORM:

JOHN ADAMS. THOMAS JEFFERSON.

JAMES MADISON. JAMES MONROE.

THE ELECTORAL VOTE.

IF THE VOTE OF ALL THE STATES IS ALLOWED, WILL STAND AS FOLLOWS:

Alabama	8	Missouri	11
Arkansas	5	Nebraska	3
California	5	Nevada	3
Connecticut	6	New Hampshire	5
Delaware	3	New Jersey	7
Florida	3	New York	33
Georgia	9	North Carolina	9
Illinois	16	Ohio	21
Indiana	13	Oregon	3
Iowa	8	Pennsylvania	26
Kansas	3	Rhode Island	4
Kentucky	11	South Carolina	6
Louisiana	7	Tennessee	10
Maine	7	Texas	6
Maryland	7	Vermont	5
Massachusetts	12	Virginia	10
Michigan	8	West Virginia	5
Minnesota	4	Wisconsin	8
Mississippi	7		

Whole number 317
Necessary to a choice 159

Dates of Birth and Death of Presidents of the U. S.

		BORN	DIED
1.	GEORGE WASHINGTON	February 22, 1732	December 14, 1799
2.	JOHN ADAMS	October 19, 1735	July 4, 1826
3.	THOMAS JEFFERSON	April 2, 1743	July 4, 1826
4.	JAMES MADISON	March 5, 1751	June 28, 1836
5.	JAMES MONROE	March 16, 1761	July 4, 1831
6.	JOHN Q. ADAMS	July 11, 1767	February 23, 1848
7.	ANDREW JACKSON	March 15, 1767	June 8, 1845
8.	MARTIN VAN BUREN	December 5, 1782	July 24, 1862
9.	WM. H. HARRISON	February 9, 1773	April 4, 1841
10.	JOHN TYLER	March 29, 1790	January 17, 1862
11.	JAMES K. POLK	November 2, 1775	June 15, 1849
12.	ZACHARY TAYLOR	September 24, 1784	July 9, 1850
13.	MILLARD FILLMORE	February 7, 1800	
14.	FRANKLIN PIERCE	November 23, 1804	
15.	JAMES BUCHANAN	April 13, 1791	June 1, 1868
16.	ABRAHAM LINCOLN	February 12, 1809	April 15, 1865
17.	ANDREW JOHNSON	December 29, 1808	

General Grant's Letter of Acceptance.

To GEN. JOSEPH R. HAWLEY, President National Union Republican Convention:

WASHINGTON, D. C., May 29, 1868.

With great respect, your obedient servant,
U. S. GRANT.

Speaker Colfax's Letter of Acceptance.

Hon. J. R. HAWLEY, President of the National Union Republican Convention:

Very truly yours,
SCHUYLER COLFAX.

JOHN Q. ADAMS. ANDREW JACKSON.

MARTIN VAN BUREN. WM. H. HARRISON.

POPULAR VOTE FOR PRESIDENT.

Result of Presidential Elections in U. S. from 1796 to '60.

JOHN TYLER. JAMES K. POLK. ZACHARY TAYLOR. MILLARD FILLMORE. FRANKLIN PIERCE. JAMES BUCHANAN. ABRAHAM LINCOLN. ANDREW JOHNSON.

Published by H. H. LLOYD & CO., 21 John Street, New York; B. B. RUSSELL, 55 Cornhill, Boston; D. L. GUERNSEY, Concord, N. H.

Agents wanted to sell this and many other new and popular works.

1868

Ulysses S. Grant (Republican) v. Horatio Seymour (Democrat)

"[Grant] has nothing to say and keeps on saying it day in and day out."

—Democratic Party pamphlet, 1868

Electoral Votes	Popular Votes
Grant 214	Grant 3,013,650
Seymour 80	Seymour 2,708,744

An info- and image-packed document, the 1868 "Republican Chart" has, as its central feature, images of the party's presidential candidate, the heretofore nonpolitical Gen. Ulysses S. Grant, and his running mate, veteran Indiana congressman and former Speaker of the House Schuyler Colfax. In addition, the broadside includes texts of the Republican platform as well as the candidates' letters of acceptance. "If elected to the office of President of the United States," Grant wrote, "it will be my endeavor to administer all the laws in good faith . . . and with the view of giving peace, quiet, and protection everywhere."

Peace and quiet undoubtedly sounded like just the ticket to weary voters. In the three years since Grant had led Union armies to victory in the Civil War, contention over Reconstruction policies had carved deep and dangerous chasms not only between Republicans and Democrats in general but also between the southern Jacksonian Democratic president Andrew Johnson and Republicans in Congress, where that party enjoyed an overwhelming majority. These differences formed the basis for Johnson's impeachment and near conviction, a rending process that ended only four days before the May 20 start of the Republican national convention in Chicago.

Reconstruction troubles had nudged Grant closer to politics the year before, when he took a well-publicized part in the formulation and passage (over the president's veto) of the Military Reconstruction Act of 1867, legislation that effectively placed the former Confederate states under martial law, principally to protect the rights and lives of freedmen. Later, as Johnson's impeachment loomed and while still in command of the U.S. Army, Grant served briefly and unhappily as Johnson's interim secretary of war; it was during this tenure that he became thoroughly disenchanted with the president.

By the time of the Republican convention, which was the first to include black delegates (twelve total, all from southern states), Grant's stature and honorable behavior during the multiple crises of the Johnson years had made him the only logical candidate for the nomination. Maintaining tradition, and in deference to what he considered his own dearth of oratorical and political skills, Grant left most of the campaigning to others. On election day, with the help of some 450,000 to 500,000 African American votes in southern states (cast despite a bloody campaign of Ku Klux Klan terrorism), the celebrated military leader won the presidency.

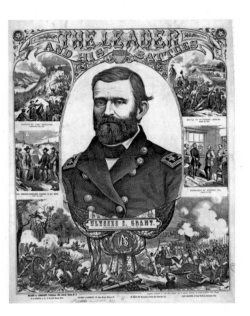

The Leader and His Battles: Ulysses S. Grant, Lieutenant-General U.S.A., lithograph, c. 1866. With the victories of Vicksburg and Appomattox under his belt, Grant was able to garner support based on his self-sacrificing service during the Civil War.

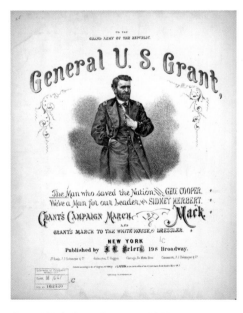

General U. S. Grant, lithograph, 1868. Featured on the sheet-music cover for four campaign songs, including "Grant's Campaign March" and "The Man Who Saved the Nation," this portrait of the general in uniform was no doubt calculated to win the hearts, patriotism, and votes of Union veterans and grateful civilians.

1884

Grover Cleveland (Democrat) v. James G. Blaine (Republican)

"Party contests have never before reached so low a depth of degradation in this . . . country."

—The Nation

Electoral Votes	Popular Votes
Cleveland 219	Cleveland 4,874,621
Blaine 182	Blaine 4,848,936

Following the assassination of James Garfield by a deranged would-be civil servant, both political parties set out on the path to reform. Because President Chester Arthur, Garfield's successor, was identified with the traditionalist Stalwart wing of the Republican Party, in 1884 the Republicans turned to a new candidate: James G. Blaine of Maine. Blaine was wildly popular with a large segment of the party, but not with the most determined of reformers. A cloud had hung over him since his previous bid for the White House in 1876, when letters materialized documenting his questionable relationships with railroad interests. (In one communication, Blaine urged the recipient to "burn this letter.")

Blaine's nomination led reform-minded Republicans to break party lines and support the Democrat instead. That man was forty-seven-year-old Grover Cleveland, governor of New York. One of that city's newspapers offered four reasons for endorsing Cleveland: "1. He is an honest man. 2. He is an honest man. 3. He is an honest man. 4. He is an honest man." That honesty was soon put to the test. On July 21, a Buffalo newspaper published what it called "A Terrible Tale: A Dark Chapter in a Public Man's History." The article claimed that, as a young man, Cleveland had taken up with a thirty-six-year-old widow, fathered a son, and continued to support them financially. Cleveland confirmed the story; when his campaign staff asked how they should handle the affair, he said, "Above all, tell the truth."

Thus began one of the dirtiest campaigns in American history. With both parties agreeing on the need for reform and the country at peace, the issue of character dominated. The *New York Sun* described Cleveland as a "coarse debauchee who would bring his harlots with him to Washington." Among Cleveland's defenders was Mark Twain, who retaliated in kind, saying that he found Blaine's lying about his record so offensive that "I don't seem able to lie with any heart, lately."

Blaine seemed to be in the lead until October 29. On that day he attended a meeting of Protestant ministers, one of whom declared, "We are Republicans and don't propose to leave our party and identify ourselves with the party whose antecedents have been rum, Romanism, and rebellion." Romanism was a thinly veiled reference to Catholics, and Blaine's strong support among New York's Irish Catholic voters began to waver when he was slow to disavow the remark. It didn't help that, the very same evening, Blaine attended a dinner at the city's fanciest restaurant, Delmonico's, with Jay Gould, John Jacob Astor, and other plutocrats. In a shaky economy, such excess came off as insensitive.

The election was a squeaker—Cleveland won New York by fewer than 1,200 votes. Victory was sweet. In taunting Cleveland during the campaign over his scandalous past, Republicans had chanted: "Ma! Ma! Where's my Pa?" Now, after winning, Democrats chanted in reply: "Gone to the White House. Ha! Ha! Ha!"

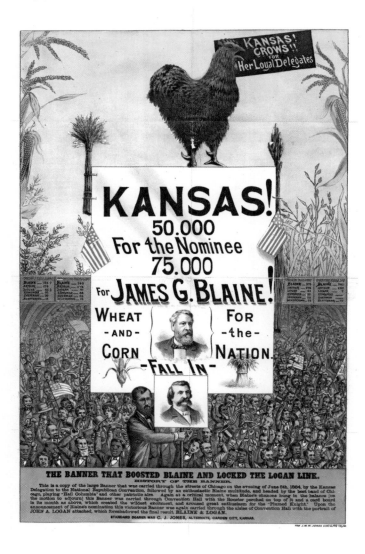

The Banner That Boosted Blaine, chromolithograph, 1884. In a rare political move, James G. Blaine won the presidential nomination over incumbent president Chester A. Arthur. This poster shows the victory banner carried by the Kansas delegation.

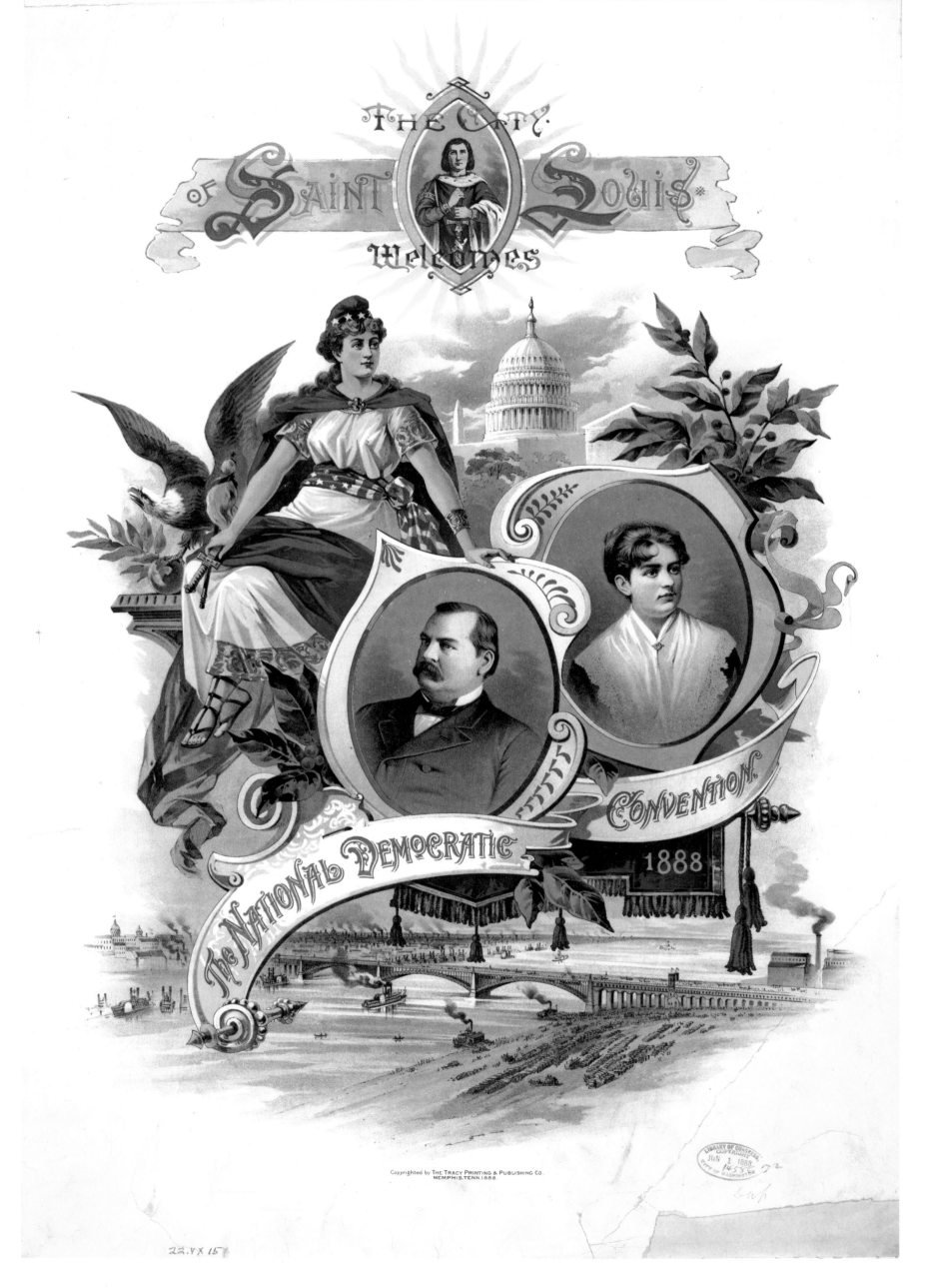

63

1888

Benjamin Harrison (Republican) v. Grover Cleveland (Democrat)

Steamboat coming 'round the bend;
Good-bye, old Grover, good-bye
Filled up full with Harrison's men;
Good-bye, old Grover, good-bye!

—*From the song "The Great Moving Day"*

Electoral Votes	Popular Votes
Harrison 233	Harrison 5,443,892
Cleveland 168	Cleveland 5,534,488

Grover Cleveland's 1886 marriage to twenty-one-year-old Frances Folsom made her the youngest first lady in history, and her popularity with the American people convinced advertisers that her likeness could sell almost anything. It's no wonder that, when posters were developed for the national Democratic convention in Saint Louis, the pols saw fit to prominently display Frances's image alongside the president's. It might also explain why the poster's depiction of Lady Liberty, whose hand rests approvingly on top of Cleveland's portrait, bears a striking resemblance to the first lady.

Despite Frances's popularity—or, presumably, because of it—a tabloid rumor started circulating the nation that, behind the scenes in the White House, Cleveland frequently got drunk and beat his wife in fits of rage. Partisan journalists took to calling Cleveland the "Beast of Buffalo." Eventually, his wife found it necessary to issue a statement refuting the charge, saying it was a "foolish campaign story without a shadow of foundation."

Beast or no, the president easily secured the Democratic nomination for reelection. The Republicans, however, had a harder time. Meeting in Chicago, they needed seven ballots before finally nominating Benjamin Harrison, a former U.S. senator from Indiana, veteran Civil War general, and grandson of the country's ninth president, William Henry Harrison. The big issue dividing the two candidates was their position on taxing foreign imports: Cleveland opposed tariffs, whereas Harrison, a strict protectionist, favored them. Harrison's popular "pro-American" stance, combined with the superior organization and funding of the Republican Party (they raised $3 million, a record at the time), made him a formidable opponent.

In the end, Cleveland won the popular vote, but Harrison garnered enough electoral votes to win the presidency, a feat that wouldn't be repeated until the twenty-first century, when George W. Bush defeated Al Gore. And, much like the partisan fever that marked the 2000 election, Harrison's supporters celebrated the close win gleefully, engaging in such revelry as the song "The Great Moving Day," whose sheet-music cover depicts Cleveland struggling to carry his political baggage out of the White House.

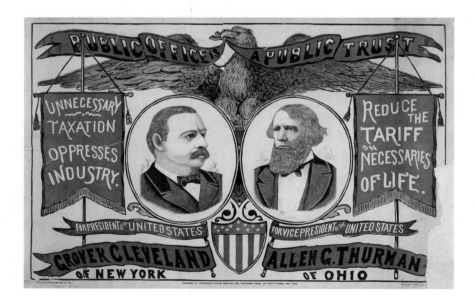

Public Office Is a Public Trust, campaign poster, 1888. Cleveland's running mate in 1888 was Ohio senator Allen G. Thurman; Vice President Thomas Hendricks had fallen ill and died while in office.

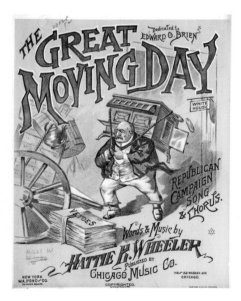

The Great Moving Day, cover of sheet music published by the Chicago Music Company, 1888. Republicans celebrated Cleveland's exit from the White House after only one term.

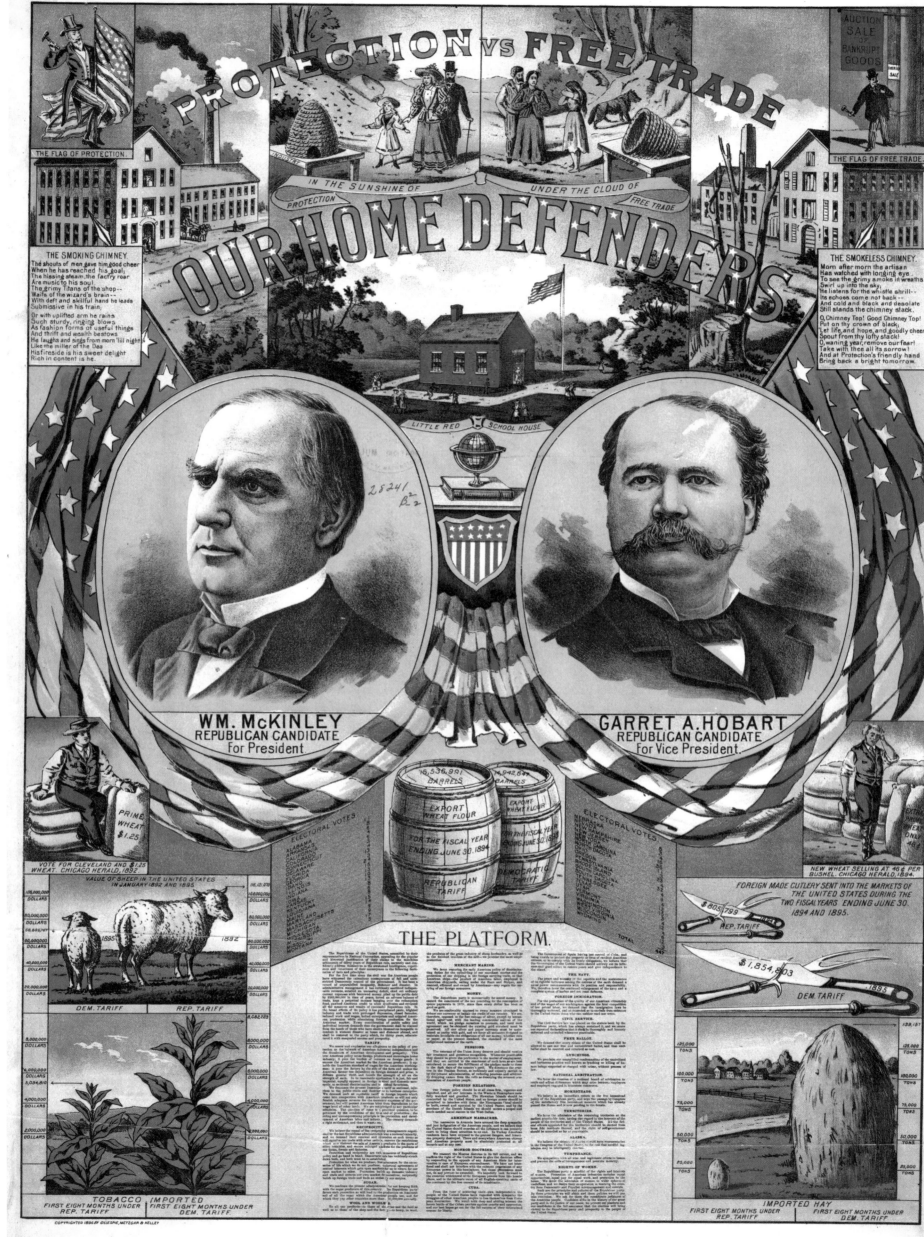

1896

William McKinley (Republican) v. William Jennings Bryan (Democrat/Populist)

"Our currency today is good— all of it is as good as gold."

"McKinley and the Full Dinner Pail"

—Republican campaign slogans

Electoral Votes	Popular Votes
McKinley 271	McKinley 7,108,480
Bryan 176	Bryan 6,511,495

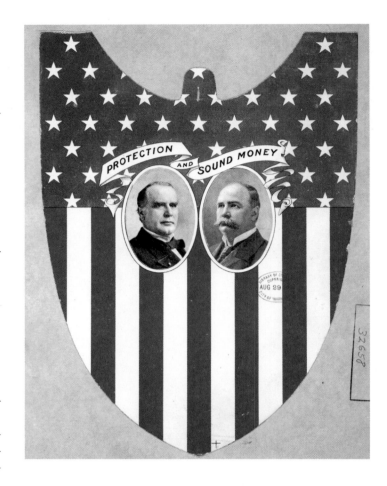

Protection and Sound Money, photomechanical print, 1896. In contrast to William Jennings Bryan's liberal economic reforms, William McKinley took a more conservative approach.

The campaigns waged by Republicans and Democrats in 1896 mirrored their respective positions on the election's main issue: the economy. The Democratic Party formulated a radical platform and amassed support behind William Jennings Bryan, the youngest presidential candidate ever nominated by a major party. They supported free trade and the unlimited coinage of silver, extreme views compared to the prevailing protectionist trade policies and gold standard for currency. By contrast, the Republican platform stood for "protection and sound money"—that is, tariffs on foreign goods and the retention of the gold standard—as seen on their red, white, and blue campaign shield (*right*) bearing images of presidential candidate William McKinley and vice-presidential candidate Garret Hobart. The party's precise, well-funded, and calculated campaign contrasted strikingly with the freewheeling style of Bryan and the Democrats.

McKinley, who was nominated at the Republican convention on the first ballot, conducted a front-porch-style campaign similar to the ones fellow Republican Benjamin Harrison had undertaken in 1888 and 1892. Meanwhile, Republican National Committee chairman Mark Hanna carefully crafted messages such as those seen in the "Our Home Defenders" poster depicting working factories and valuable American goods. Hanna, a millionaire, revolutionized the role of campaign manager by raising substantial funds from banks and industry and orchestrating a preconvention strategy using campaign spending to ensure that his handpicked candidate would represent the party line. The Republican Party amassed a campaign treasury of $3.5 million, compared to the Democrats' budget of $650,000; in addition, Hanna arranged for more than 300 delegations of farmers, businessmen, workers, veterans, and college stu-

dents—totaling 750,000 Americans from thirty states—to visit McKinley's home in Canton, Ohio. Republicans also distributed 250 million campaign items, including pamphlets, posters, banners, and buttons and organized speakers to espouse their party's message on the campaign trail. The material overwhelmed the electorate of 14 million.

McKinley's campaign proved the importance of a strong team rather than just a strong candidate. As the election approached, the economy showed signs of improvement, lending momentum to McKinley's bid for the White House. In the end, McKinley won the presidency, emerging victorious in every state north of Virginia and east of Missouri.

87

1912

Woodrow Wilson (Democrat) v. Theodore Roosevelt (Progressive) v. William Howard Taft (Republican) v. Eugene V. Debs (Socialist)

"Every illegitimate force instinctively dreads the possibility of my becoming President. They know that I am 'on to them' and that I can neither be fooled nor bought."

—*Woodrow Wilson, in a letter to Mary Ellen Hulbert Peck, December 10, 1911*

Electoral Votes	Popular Votes
Wilson 435	Wilson 6,293,152
Roosevelt 88	Roosevelt 4,119,207
Taft 8	Taft 3,486,333
Debs 0	Debs 900,369

The front-runners of the four-way contest for the presidency in 1912 included neither the incumbent Republican president, William Howard Taft, nor Socialist Party candidate, Eugene V. Debs. Rather, the buzz centered on a different pair: former president Teddy Roosevelt—seeking to reclaim the White House after spending four years disappointed in his successor's performance—and Democrat Woodrow Wilson. A shooting star in his party's firmament, the scholarly and idealistic Wilson gained national attention as the first nonclerical president of Princeton University (1902–10). His considerable public-speaking skills, along with the reputation he had established through publishing academic studies on the federal government, won him the New Jersey governorship in 1910, which in turn propelled him to the 1912 Democratic presidential ticket. Wilson was not a shoo-in at the convention, however. It took patience, skill, and the support of the venerable William Jennings Bryan to help him overcome candidates backed by New York's Tammany Hall political machine; he won the nomination on the forty-sixth ballot. For Wilson's running mate, the convention selected Indiana's Progressive governor, Thomas R. Marshall. Possessed of a wry sense of humor, Marshall was widely known for his deadpan declaration, "What this country needs is a good five-cent cigar."

Matching Wilson in idealism, bounding well past him in exuberance and political experience, and possessing ample courage, Roosevelt suffered from not only the splintering of the Republican Party (divided between his candidacy and Taft's) but also his acceptance of federally regulated business trusts. Wilson took exception to that idea, arguing: "When once the government regulates the monopoly, then monopoly will have to see to it that it regulates the government." In this reform-minded era, when working people struggled against the disproportionate power of big business, Wilson won widespread support. Though he required tutoring during the campaign on the fine points of economic policy, he benefited from the fractured Republican Party as well as his own earnest oratory and became only the second Democrat elected president since the Civil War.

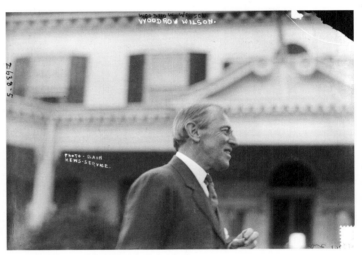

Woodrow Wilson a few hours after nomination, photograph, 1912. Wilson capitalized on a split in the Republican Party to sweep the vote.

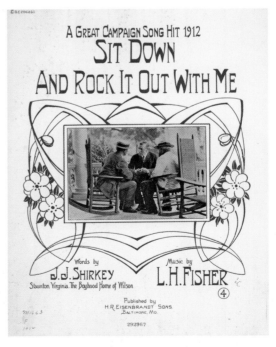

Sit Down and Rock It Out with Me, cover of sheet music published by H. R. Eisenbrandt, 1912. Wilson shows his softer side here, rocking with potential voters on the porch of his New Jersey home.

TRIPLICITY
OR THE
Donkey, MOOSE or Elephant

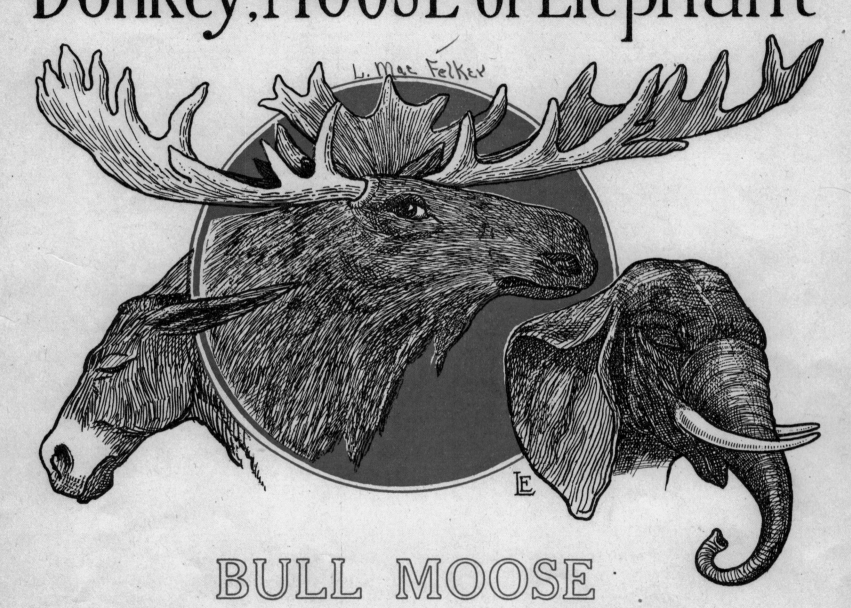

L. Mac Felker

BULL MOOSE
CAMPAIGN SONG

PRICE 50c

MAXWELL SALES COMPANY, 1451 BROADWAY, NEW YORK

293959

1912

Woodrow Wilson (Democrat) v. Theodore Roosevelt (Progressive) v. William Howard Taft (Republican) v. Eugene V. Debs (Socialist)

"Thou wilt not cower in the dust,
Roosevelt, O Roosevelt!
Thy gleaming sword shall never rust
Roosevelt, O Roosevelt!"

—Sung by delegates at the Progressive convention, 1912

Electoral Votes	Popular Votes
Wilson 435	Wilson 6,293,152
Roosevelt 88	Roosevelt 4,119,207
Taft 8	Taft 3,486,333
Debs 0	Debs 900,369

Theodore Roosevelt—the larger-than-life leader of the Rough Riders during the Spanish-American War, prolific author, Nobel Peace Prize winner, political reformer, and two-term U.S. president—vacated the White House in March 1909, confident that his hand-picked successor, William Howard Taft, would continue his progressive policies. When Taft fell short of expectations, Roosevelt once again sought the Republican nomination in 1912. It was the first year that primary elections played an important role in the election process, and Roosevelt proved much more popular than Taft among grassroots Republicans. Conservative influences controlled the party machinery, however, and Taft prevailed at the national convention. "I expect to be nominated for president, and I want to be," Taft said at the time, "to keep Theodore Roosevelt from wrecking the Republican Party."

In 1912, the country rang with cries to end the power of special interests and increase social justice. Within two months, disgruntled Republicans, reformers, feminists, and other supporters of Roosevelt's political vision (dubbed the "New Nationalism") had formed the Progressive Party. At their boisterous Chicago convention, they named Roosevelt as their candidate and selected California's Hiram Johnson as his running mate. The addition of Roosevelt, along with the unusually strong support for Socialist candidate Eugene V. Debs, set the stage for one of the most complex and

riveting presidential campaigns in American history. A characteristically boisterous utterance from Roosevelt ("I'm feeling like a bull moose!") gave the newly formed party both its symbol and its informal name. In October of election year, he proved as strong as his party's namesake. Seriously wounded in an assassination attempt while en route to a speaking engagement, Roosevelt refused treatment until after he had delivered his one-and-a-half-hour address. When Roosevelt took time off to recover, both Taft and Wilson suspended their own campaigns, refusing to take advantage of their rival's incapacitated state.

Unpopular and unenthusiastic except in his desire to see Roosevelt defeated, Taft quickly devolved into a minor force in the campaign, which became a contest between the two progressives, Roosevelt and Wilson. Each advocated a different approach to reform. In the end, the cleft in the Republican Party, coupled with Wilson's earnest eloquence, proved impossible for Roosevelt to overcome. "The fight is over," he said when the returns were in. "We are beaten."

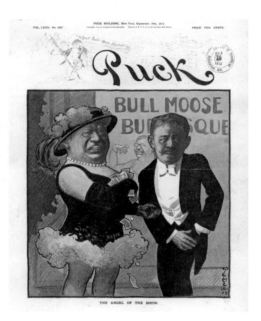

The Angel of the Show, photomechanical print by W. E. Hill, 1912. In this "Bull Moose Burlesque," Roosevelt is a dancer receiving tips (funds) from George Perkins, an official of his Progressive Party.

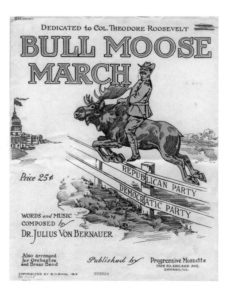

Bull Moose March, cover of sheet music published by Progressive Morsette, 1912. Roosevelt soars above the Republican/Democratic fence on an awkward mount.

PROGRESSIVE

FOR PRESIDENT
ROBERT M. LaFOLLETTE

1924

Calvin Coolidge (Republican) v. John W. Davis (Democrat) v. Robert M. La Follette (Progressive)

"The great issue before the American people today is the control of government and industry by private monopoly."

—*Opening line of the Progressive Party platform*

Electoral Votes	Popular Votes
Coolidge 382	Coolidge 15,723,789
Davis 136	Davis 8,386,242
La Follette 13	La Follette 4,831,706

Two short-lived groups marking their first presidential campaigns in 1924—the new Progressive Party and the American Party (led by legendary statesman Robert La Follette and small-town judge Gilbert O. Nations, respectively)—represented a pair of diametrically opposed undercurrents flowing through post–World War I society: reform and retrenchment. Jalopy-driving, bobbed-haired Americans were shaken by the Red Scare on one hand and the Charleston on the other; religious revivals battled with college football for the country's devotion; and many voters publicly supported Prohibition while secretly consuming vast quantities of illegal beverages.

Into this milieu charged "Fighting Bob" La Follette, depicted in this campaign poster flanked by a Liberty Bell motif. Sporting a snowdrift coiffure, the Wisconsin Republican led a coalition of liberals, reformers, and former Bull Moose Party supporters under a Progressive banner that called for railroad regulation reform, tax cuts, labor rights, and benefits for war veterans. Women occupied many high-ranking positions on his campaign committees, and La Follette employed a new technology—radio—to broadcast his message. John Davis, the Democratic nominee, marveled at the impact that La Follette's wireless blitz had on the airwaves. "Radio will change the whole plan of all our campaigns," he told the *Boston Daily Globe* in July. "They'll tune out on us if we talk too long, and we'll never know it. Just a turn of the wrist and the long-winded candidate is off and jazz is on."

At the other end of the political spectrum was Gilbert Nations of Missouri, head of the American Party. He admitted that his party's platform was similar to one espoused by the Ku Klux Klan, then near the height of its popularity, but denied any affiliation with the group. As leader of a small party, Nations was compelled to hit the campaign trail hard, which took him to seldom-visited territory, such as Atlanta. "It is not customary for either the Democratic or the Republican candidates to visit Georgia during the quadrennial campaign," the *Atlanta Constitution* told its readers. "The former feels that it is unnecessary, and the latter feels that it is useless."

La Follette ran an especially strong third-party campaign, winning 17 percent of the vote, but the coalition dissolved soon after the election, and he died within a year. Nations secured a mere .08 percent of the vote.

Robert M. La Follette, photograph, 1924. Pugnacious enough to earn the nickname "Fighting Bob," La Follette campaigned with vigor in 1924.

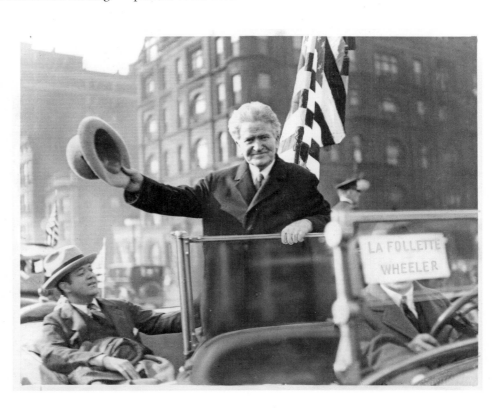

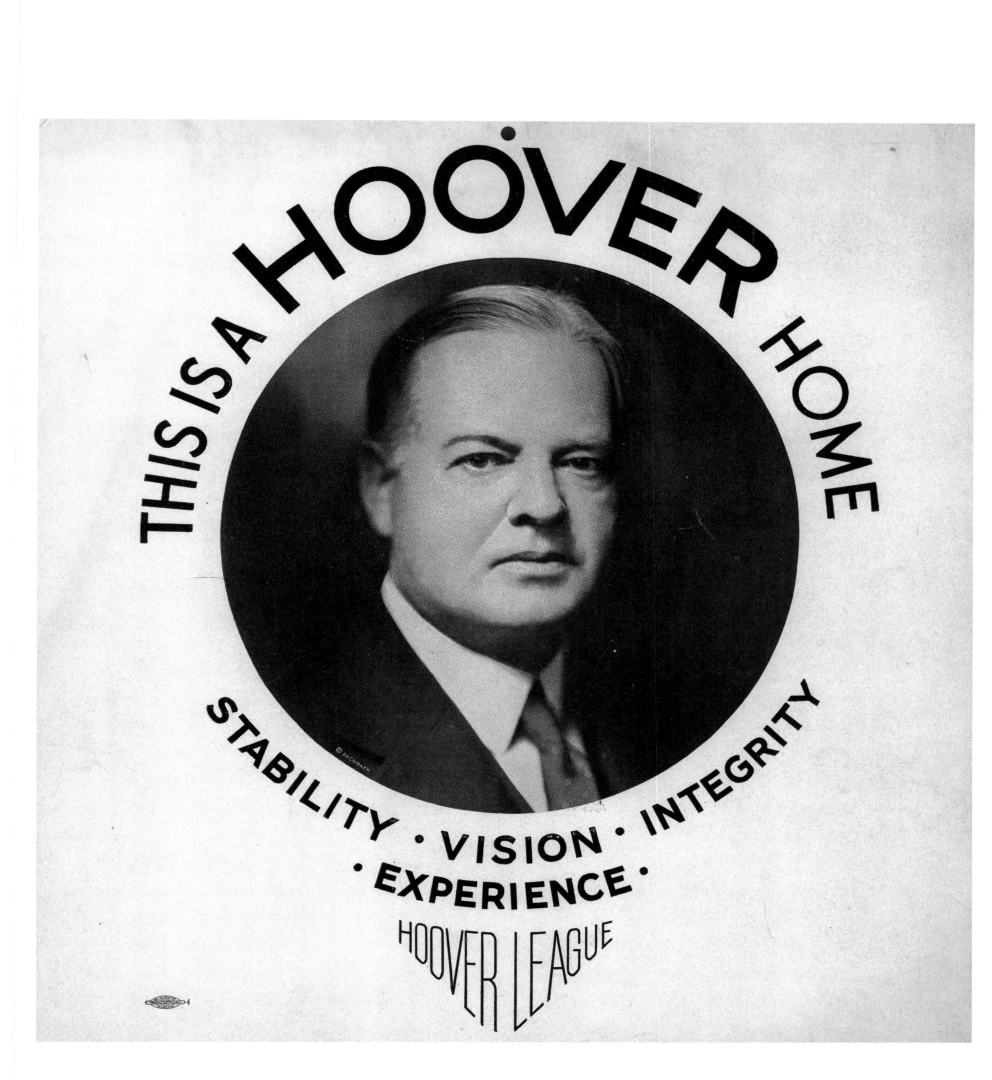

THIS IS A HOOVER HOME

STABILITY · VISION · INTEGRITY
· EXPERIENCE ·

HOOVER LEAGUE

FOR PRESIDENT

WENDELL L. WILLKIE

For President: Wendell L. Willkie, photographic print, c. 1940

13

1940

Franklin D. Roosevelt (Democrat) v. Wendell Willkie (Republican)

"Who really thinks the President is sincerely trying to keep us out of war?"

—*Wendell Willkie*

Electoral Votes	Popular Votes
Roosevelt 449	Roosevelt 27,313,041
Willkie 82	Willkie 22,348,480

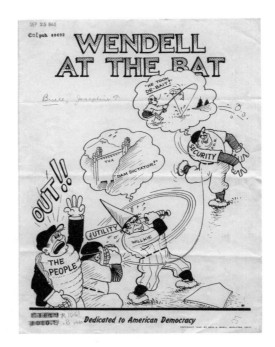

Wendell at the Bat, cover of sheet music published by Odin G. Buell, 1940. Wendell Willkie, the Republican challenger to FDR in 1940, couldn't step up to the plate, striking out with the American umpire.

A sitting president running for an unprecedented third consecutive term against a political neophyte: the 1940 election sure sounded like a mismatch. And it did indeed result in another runaway victory, though not without plenty of drama along the way.

At first, President Franklin D. Roosevelt was uncertain whether to run for reelection, but as Germany became an increasingly powerful threat in Europe, he decided to try to remain in office and guide the country through what would surely be treacherous times ahead. Roosevelt was determined to jettison his vice president, John Nance Garner, who often disagreed with the president's New Deal policies, and replace him with the more liberal Henry Wallace. He made it clear he would refuse the nomination without Wallace on the ticket, and ultimately he got his way.

Nomination theatrics also plagued the Republicans in the contest between Ohio senator Robert A. Taft and New York attorney general Thomas E. Dewey. Both men had limited appeal, and a dark horse quickly emerged: utilities businessman Wendell Willkie of Indiana. A former Democrat, Willkie had supported Roosevelt in 1932 but lost faith after what he regarded as the government's encroachment on free enterprise. He not only switched parties but also mounted a grassroots campaign for president, despite never having held public office. When media moguls such as *Time* magazine's Henry Luce latched onto Willkie as the man to beat Roosevelt, the groundswell was under way.

The Republicans attacked the president for wanting to lead the country into the war in Europe. Roosevelt launched a counteroffensive, promising American mothers and fathers that he would "not . . . send your boys into any foreign wars." Willkie, who liked to speak off the cuff, made several gaffes while campaigning, including a poorly worded pledge to appoint a secretary of labor who was from the ranks of organized labor "and not a woman." Frances Perkins, Roosevelt's labor secretary, reported to her boss's delight that

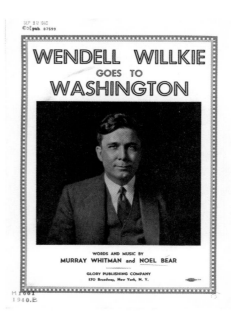

Wendell Willkie Goes to Washington, cover of sheet music published by Glory Publishing, 1940. Willkie entered the 1940 presidential race having never run for public office, a rarity in Washington.

she had received hundreds of letters and telegrams from women critical of Willkie, half of them identifying themselves as Republicans.

Roosevelt carried thirty-eight states but drew 400,000 fewer popular votes than in the election of 1932, although he still dominated Willkie and the Republicans in every region except the Plains states. Thirteen months later, after Japan's attack on Pearl Harbor, Roosevelt reneged on his campaign pledge to American parents, and the United States entered the war.

I WANT YOU F.D.R.

STAY AND FINISH THE JOB!

INDEPENDENT VOTERS' COMMITTEE OF THE ARTS *and* SCIENCES *for* ROOSEVELT

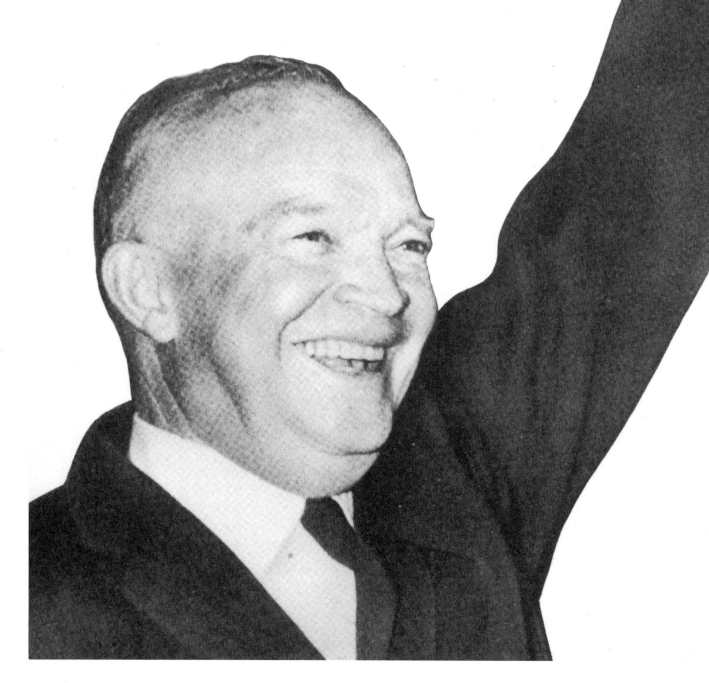

1956

Dwight D. Eisenhower (Republican) v. Adlai E. Stevenson (Democrat)

> "Modern Republicanism has now proved itself and America has approved of modern Republicanism."
>
> —Dwight D. Eisenhower

Electoral Votes	Popular Votes
Eisenhower 457	Eisenhower 35,590,472
Stevenson 73	Stevenson 26,022,752

American voters had a sense of déjà vu in 1956, when the same candidates running for president produced the same result: a landslide victory for Dwight D. Eisenhower. His second-time Democratic opponent, former Illinois governor Adlai E. Stevenson, chose a different running mate—as Ike almost did, too—but four years of peace and prosperity didn't give Stevenson much traction against the immensely popular war-hero-turned-president.

Eisenhower had originally planned to serve only one term, but apparently the job grew on him, and in March 1956 he announced he would run again, much to the relief of the Republican leadership. (One Republican had explained what he would do if Ike decided not to run: "When I get to that bridge, I will jump off it!") After committing to reelection, Eisenhower ordered party head Len Hall to tell Vice President Richard Nixon he was off the ticket but could have a job in the Cabinet. Nixon sulked: "He's never liked me. He's always been against me." Hall, concerned that dropping Nixon might split an already divided party, commissioned a series of polls that proved the current VP ran ahead of any other possible candidates, which convinced Eisenhower to relent.

Though Stevenson announced his availability in November 1955, he had to work for the nomination. Sen. Estes Kefauver of Tennessee, who had made a name for himself with his nationally televised crime-committee hearings, emerged as his main opponent in the primaries. Yet, at the convention Stevenson secured the nomination and allowed party delegates to choose his running mate; they settled on Kefauver over another likely candidate, the young up-and-coming senator from Massachusetts, John F. Kennedy.

The campaign saw Stevenson energetically crisscrossing the country to promote his plan for a "New America," which, as one historian has pointed out, laid the groundwork for JFK's New Frontier and Lyndon Johnson's Great Society. Eisenhower kept a more modest schedule, partially in deference to his health; he had suffered a heart attack in 1955 and, in June 1956, underwent intestinal surgery. As it turned out, the president's health was one of the campaign's few substantial issues. As comic Mort Sahl joked: "Eisenhower stands for 'gradualism.' Stevenson stands for 'moderation.' Between these two extremes, we the people must choose!" They chose Ike. Again.

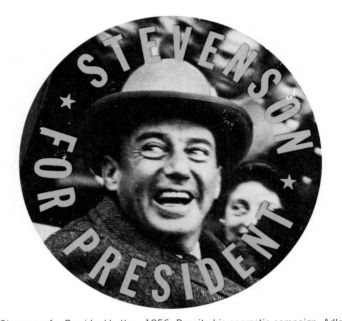

Stevenson for President button, 1956. Despite his energetic campaign, Adlai could not topple Ike.

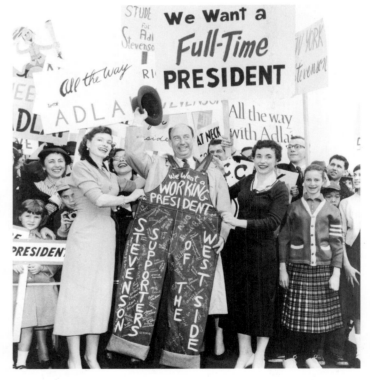

We Want a Full-Time President, photograph, 1956. Stevenson is presented with a pair of decorated blue denim overalls by supporters on LaGuardia Field in Queens, New York.

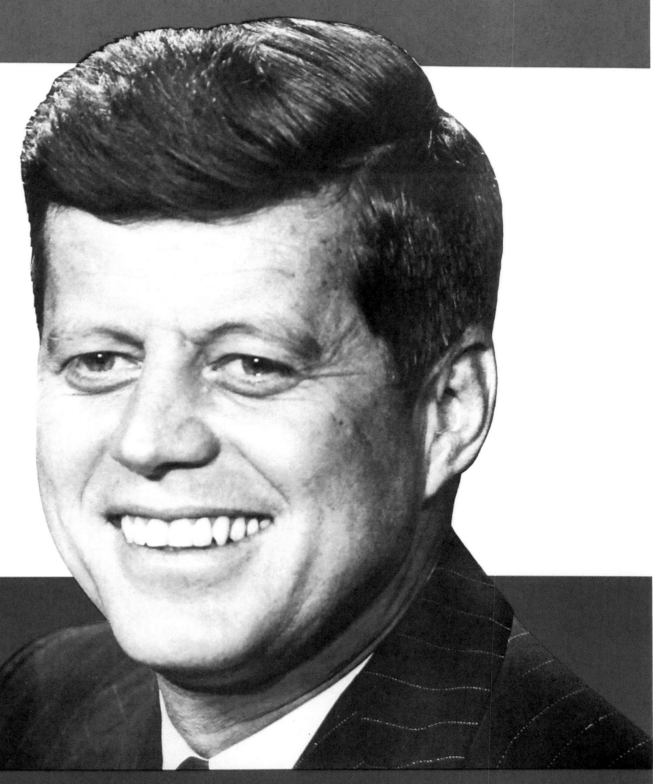

WRITE IN FOR PRESIDENT DICK GREGORY

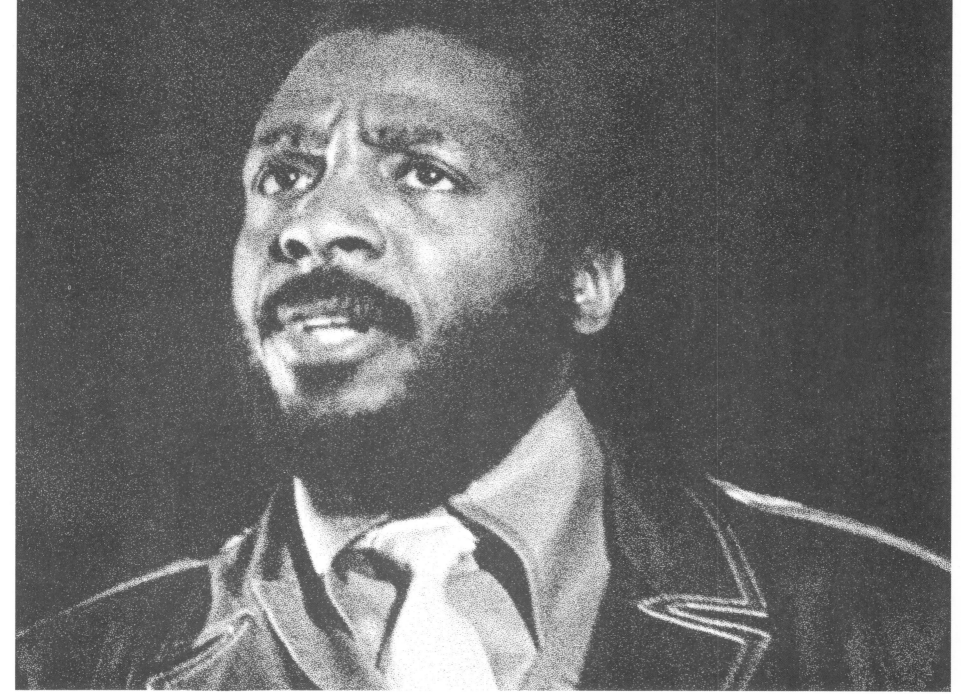

MARK LANE/VICE PRESIDENT

1968

Richard M. Nixon (Republican) v. Hubert Humphrey (Democrat) v. George Wallace (Independent)

"Hell hath no fury like a liberal scorned."

—*Dick Gregory*

Electoral Votes	Popular Votes
Nixon 301	Nixon 31,785,480
Humphrey 191	Humphrey 31,275,166
Wallace 46	Wallace 9,906,473

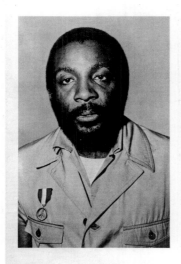

[PUBLIC CITIZEN #1 · PRESIDENT OF THE UNITED STATES IN EXILE · INAUGURATED 3-4-69]

Needed: Public Citizen #1, poster, c. 1969. This poster, sponsored by the Peace and Freedom Party, shows Dick Gregory as "president of the United States in exile."

Pat Paulsen wasn't the only humorist running for president in 1968. The other, however, wasn't laughing. Comedian Dick Gregory, an African American activist, was dead serious about his opposition to the Vietnam War and decried racism and poverty. The performer was famous for his biting wit and confrontational style; he once opened for an all-white audience with the line, "Good evening, ladies and gentlemen. I understand there are a good many Southerners in the room tonight. I know the South very well. I spent twenty years there one night."

His sincere approach to the race notwithstanding, Gregory's campaign was guilty of one amusing stunt. In an attempt to "buy" votes, he issued $1 bills that featured his head printed in place of Washington's. Some of this counterfeit currency passed into circulation and was seized by federal agents, although Gregory was never charged. Yet his nomination by the Peace and Freedom Party was not to be. His hopes were dashed by Black Panther leader Eldridge Cleaver, who claimed top spot on the ticket. Despite being passed over, Gregory went on to earn more than 47,000 write-in votes at the polls.

His presidential bid thwarted, Gregory never again pursued high office. Yet his legacy has lived on in the form of other nontrivial celebrity candidacies in the years since. In 1972, noted pediatrician Dr. Benjamin Spock picked up Gregory's left-wing mantle, campaigning for president on a platform of legalized marijuana, free medical care, and an end to the war in Vietnam. Running on the People's Party line, Spock managed to amass fewer than 80,000 votes while Republican president Richard Nixon romped on to reelection. On the right, entertainer Sonny Bono successfully won a congressional seat in 1994 (after serving four years as mayor of Palm Springs, California), while curmudgeonly *Law & Order* stalwart Fred Thompson famously flamed out in his brief, quixotic quest for the Republican presidential nomination in 2008. Of course, the most famous show-business politician of all time is Ronald Reagan, the former B-movie actor and California governor who rode his folksy persona and conservative views all the way to the White House in a landslide victory in 1980.

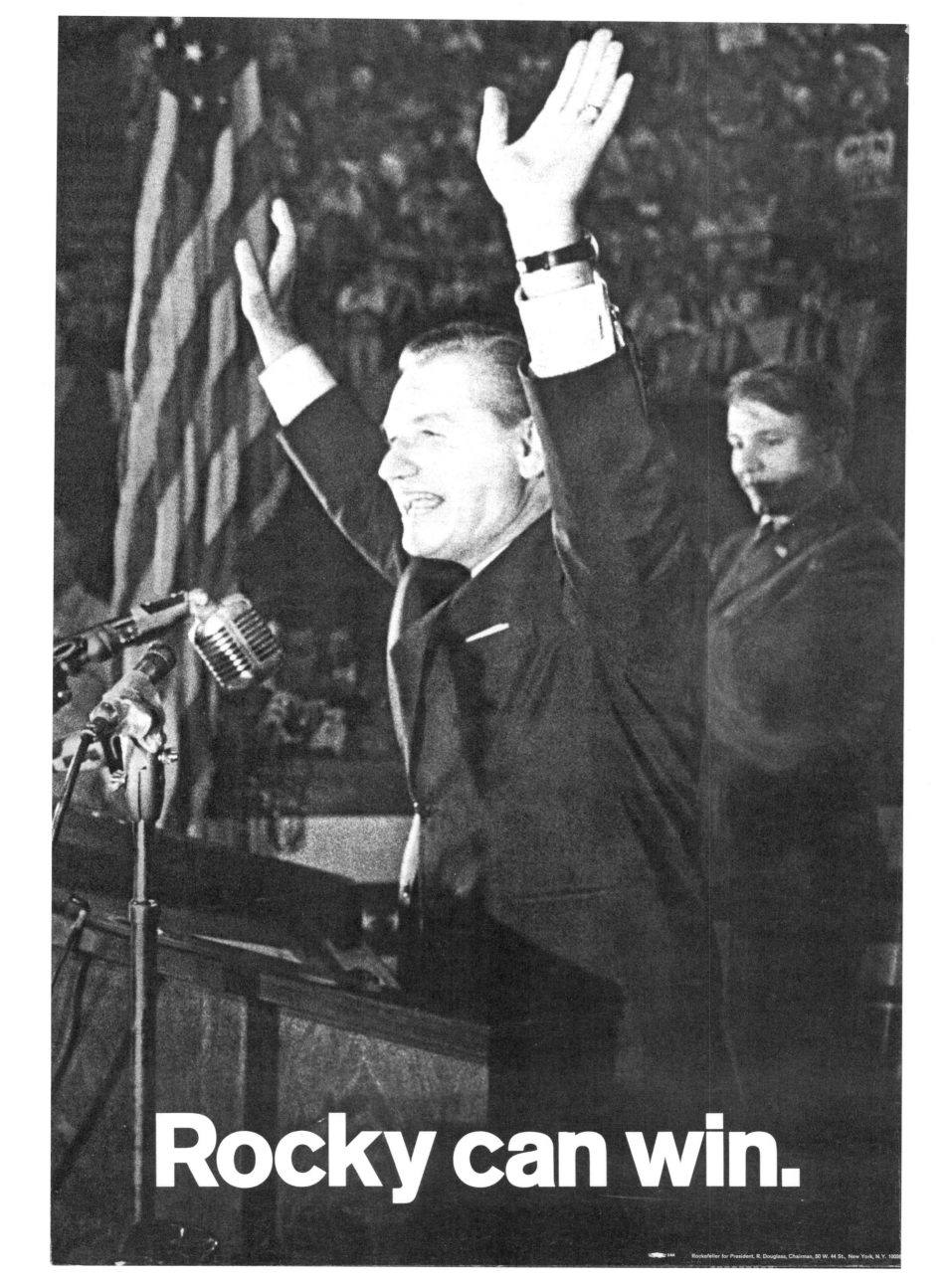

Rocky can win.

Rockefeller for President, R. Douglass, Chairman, 50 W. 44 St., New York, N.Y. 10036

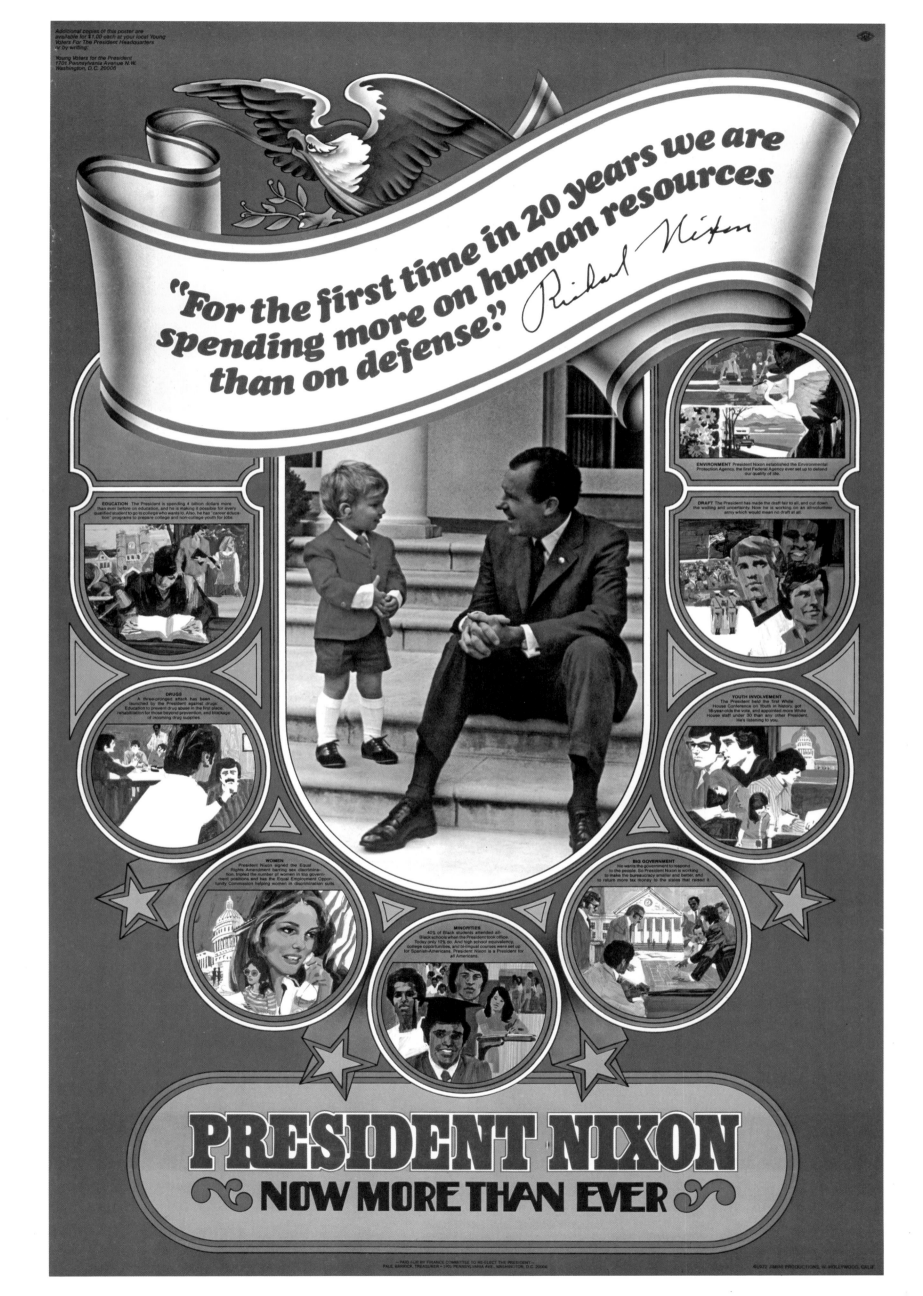

1972

Richard M. Nixon (Republican) v. George McGovern (Democrat)

"For the first time in 20 years we are spending more on human resources than on defense."

—President Richard Nixon, in a 1972 campaign poster slogan

Electoral Votes	Popular Votes
Nixon 520	Nixon 47,173,770
McGovern 17	McGovern 29,168,858

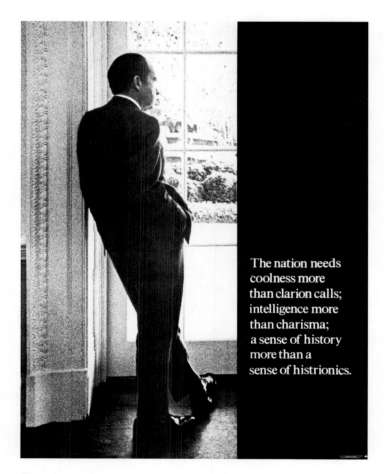

The nation needs coolness more than clarion calls; intelligence more than charisma; a sense of history more than a sense of histrionics.

The nation needs coolness . . ., poster, 1972. The message of this 1972 poster takes direct aim at George McGovern and the Democrats, who demanded an end to war.

This cheerful poster features a smiling President Nixon and a cherubic child amid pictures representing the achievements of his first term: advances in education, the war on drugs, women's rights, civil rights, bringing an end to the draft, and care for the environment. Kitschy as the image looks, its message was clear: Times are tough, but Nixon is getting the job done. Let's not stop him now.

As an incumbent president, Nixon wasn't particularly popular. That he won the 1972 election by a landslide spoke more to the state of the Democratic Party than to the public's opinion of his first term. Until then, his progress had been mixed. On one hand, the United States had sent men to the moon—a major triumph in the international space race—and Nixon had created the Environmental Protection Agency, the first government organization of its kind. On the other hand, the "peace with honor" he had promised to achieve in Vietnam remained elusive, and opposition to the war was stronger than ever. The nation had fallen into a recession, and inflation and unemployment were on the rise. In early 1972, Nixon attempted to instill confidence in voters through two historic summit trips: first to communist China and then to Russia, representing a major advance in cold war relations. It worked, and both were considered triumphs in foreign affairs.

The November Group—Nixon's in-house advertising agency that strategized his campaign—strove to show that the president was capable and moderate, all while portraying George McGovern as a radical left-wing liberal and isolationist. Nixon enjoyed support from unlikely places, notably from former Texas governor John Connally. Fearing that a McGovern presidency would tear apart the already splintered Democratic Party, Connally founded the group Democrats for Nixon, which claimed a large membership.

In the end, McGovern's grassroots campaign was no match for Nixon's well-oiled campaign machine. Not even the eighteen- to twenty-year-olds, a newly enfranchised demographic, helped McGovern's numbers; most didn't bother turning out at the polls. Nixon won 60 percent of the popular vote, one of the largest margins of any U.S. presidential election.

Angela Davis Urges Declare Your Independence

My name is Angela Davis. I'm speaking to you as a voter.
You and I know that the Democratic and Republican parties doublecross us to serve big business. That's why millions do not vote.
BUT THIS YEAR YOU CAN VOTE FOR YOUR OWN NEEDS. You can cast a loud, clear vote against big business rip-offs and coverups. The Communist Party candidates fight for a people's program of jobs, education, housing, free health care; to end wars and racism. MAKE YOUR VOTE COUNT TOWARD A NEW DIRECTION AND NEW PRIORITIES!

Gus Hall for President

Jarvis Tyner for Vice President

Vote for Hall and Tyner

If Hall and Tyner are not on the official ballot in your state, write-in their names.

Issued by: Hall-Tyner Election Campaign Committee, 156 Fifth Ave., Suite 1100, NYC 10010

212/242-5360

'76 Campaign Souvenir - $1.00

"We are in an environmental crisis because we have broken out of the Circle of Life. We are on a suicidal course. To survive, we must learn how to restore to nature the wealth we have borrowed from it."

Barry Commoner

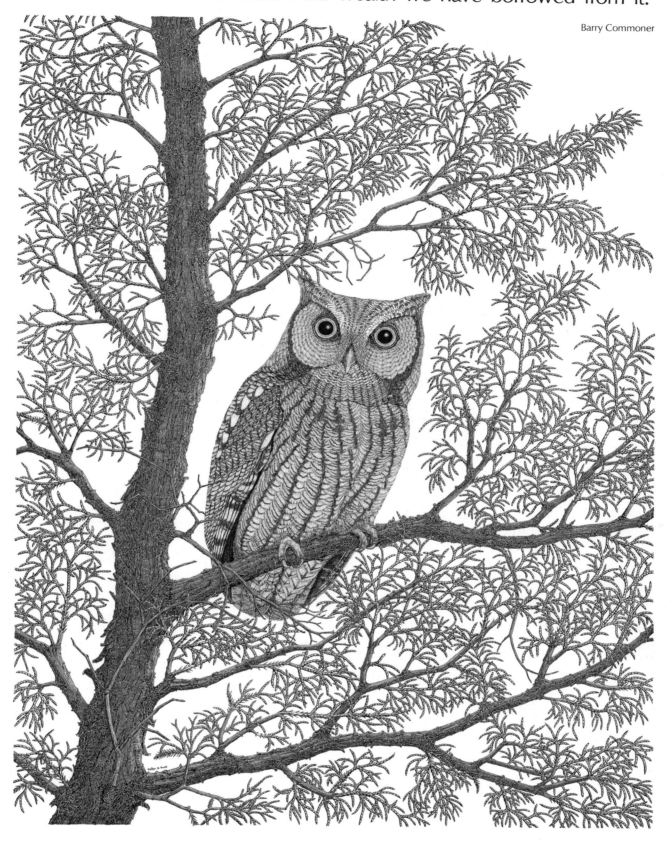

Vote Citizens Party 1980

Barry
COMMONER /
LaDonna
HARRIS

Virginia Office
P.O. Box 1145 • Falls Church, Virginia 22041
703-979-8468 / 804-649-1469

National Office
1605 Connecticut Avenue N.W. • Washington, D.C. 20009
202-234-1512

Drawing: Copyright 1980 Pieter D. Prall

1980

Jimmy Carter (Democrat) v.
Ronald Reagan (Republican) v.
John Anderson (Independent)

*"Dr. Commoner, are you a serious candidate
or are you just running on the issues?"*

—*An Albuquerque, New Mexico, television news reporter to
the Citizens' Party presidential candidate, who responded
with an "incredulous stare"*

Electoral Votes:	Popular Votes:
Reagan 489	Reagan 43,904,153
Carter 49	Carter 35,483,883
Anderson 0	Anderson 5,720,060

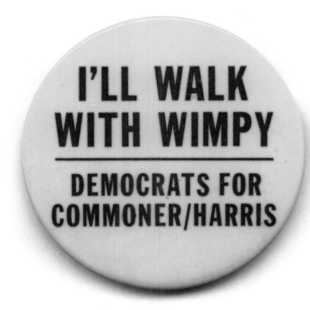

Democrats for Commoner/Harris, button, 1980. At the 1980 Democratic National
Convention, William "Wimpy" Wimpisinger, head of the machinists' union, led a
walkout of some 300 delegates to protest Carter's nomination—"Wimpy" en-
dorsed Commoner. Many machinists followed suit and proudly wore this button.

In his farewell address to the nation in 1796, George Washington warned against the dangers of political parties. Clearly, his advice has never been a deterrent, and myriad smaller parties exist outside the Democratic–Republican industrial complex. In 1980, in particular, several notable candidates with names other than Carter or Reagan appeared on the ballot for president of the United States.

The most successful of these minor candidates was former Republican congressman John Anderson of Illinois. Disenchanted with his party's rightward lurch, Anderson ran a promising campaign as an independent. In addition, the Libertarian Party, with tax-cutting peace advocate Edward Clark at the head of the ticket, had its best showing ever, winning nearly one million votes. The Socialist Party was especially noteworthy for its pioneering national slate, which included atheist David McReynolds, the first openly gay man to run for president, and his running mate, Sister Diane Drufenbrock, a Milwaukee teacher and Catholic nun.

Barry Commoner's candidacy was as uncommon as his artful yet subdued campaign poster suggests. A university science professor and the nominee of the new Citizens Party, which comprised various peace and environmental groups, Commoner spent months promoting proposals addressing nuclear proliferation, inflation, and high utility rates. But it was not until mid-October that he drew much media interest, when his party ran radio ads describing the Carter, Reagan, and Anderson campaigns as "bullshit." Thousands of listeners complained to the major networks after hearing the commercial on their news affiliates. "I don't think we have departed from appropriate language," Commoner explained. "Integrity requires us to say what we mean."

Commoner's owl was not the only fowl in the race that year; there was also an eagle, as in the Eagles' guitarist Joe Walsh, a write-in candidate. Walsh proposed replacing the national anthem with his solo hit "Life's Been Good," which includes the lyric, "They say I'm lazy, but it takes all my time." With the recent breakup of his band, Walsh was conveniently available for the chief executive position, although constitutionally he was too young to hold office. One of his supporters was Sen. Alan Cranston of California, the majority whip, who was spotted just before the Democratic convention wearing a "Joe Walsh for president" campaign button.

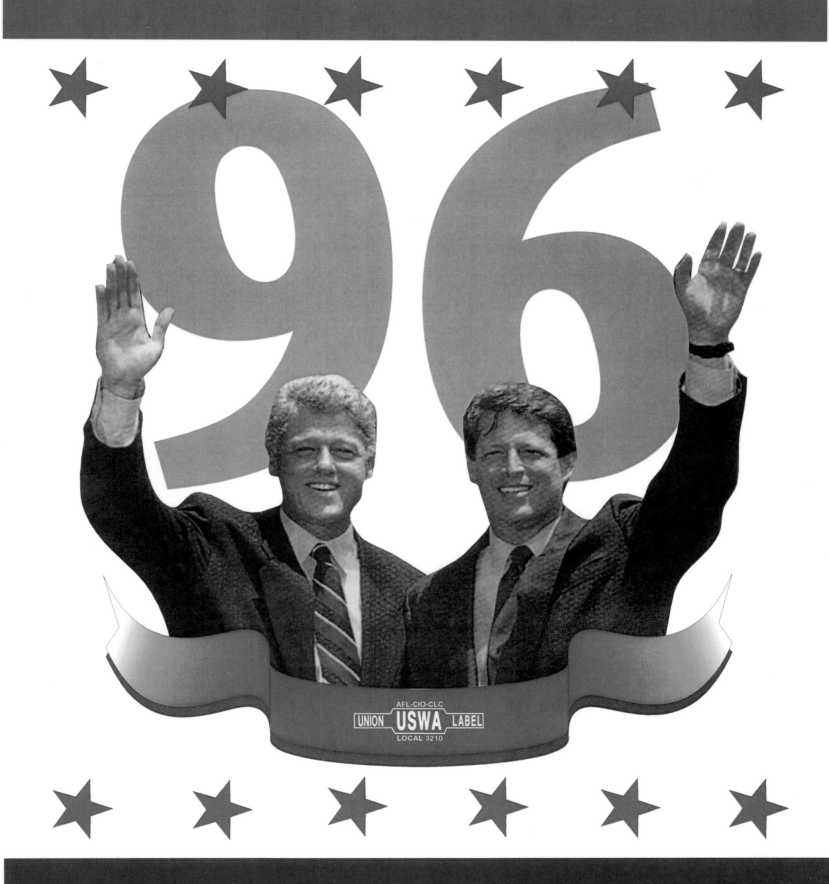

1996

Bill Clinton (Democrat) v.
Bob Dole (Republican) v.
H. Ross Perot (Reform)

"We do not need to build a bridge to the past; we need to build a bridge to the future."

—*Bill Clinton*

Electoral Votes	Popular Votes
Clinton 379	Clinton 45,590,703
Dole 159	Dole 37,816,307
Perot 0	Perot 7,866,284

American voters were suffering from a case of déjà vu in 1996, when a popular incumbent was again challenged by two opponents. Two of the three candidates were the same as in 1992: Bill Clinton and third-party gadfly H. Ross Perot. Four years later, however, Clinton resided in the White House, and, unlike George H. W. Bush in '92, there was no shaky economy to deflate his high ratings in the polls. In fact, during his presidency, Clinton had overseen a huge transformation in the economic picture: unemployment and inflation were down, and the deficit had been substantially reduced. It was a quick turnaround for the "Comeback Kid," whose lackluster first two years in office had opened the door for a Republican takeover of Congress in the 1994 midterm elections. But as budget wars with Congressional Republicans swung public favor back toward Clinton, the GOP was set back on its heels.

In the primary season, Clinton ran virtually unopposed in his party's primaries. Sen. Bob Dole of Kansas, vice president under Gerald Ford and a presidential contender in 1980 and 1988, mowed down a large field of rivals and finally grabbed his party's brass ring. And back again, this time under the banner of the Reform Party, was Perot, who had made a respectable popular-vote showing in 1992.

In his January State of the Union address, Clinton seized the initiative from the Republicans, declaring that the era of big government was over. The Democratic platform followed up on that theme by promising to balance the budget as well as reform welfare and campaign financing. When Dole subsequently proposed, "Let me be the bridge to an America that only the unknowing call myth. Let me be the bridge to a time of tranquility, faith, and confidence in action," Clinton had a ready answer: he was building a bridge to the future.

The Democrats' move to the center severely reduced the differences between the two parties in the minds of many voters and in the opinion of some political cartoonists *(see below)*. It wasn't a particularly inspiring campaign, and voter turnout reflected the lack of excitement. A total of 8.2 million fewer voters participated than in 1992, though Clinton garnered more votes than he had four years before. Perot was the big loser, dropping from almost 19 percent of the popular vote in the previous election to only 8 percent this time around. Dole won most of the South and the middle of the country, and Clinton solidified his hold on the big electoral states, adding Florida to the Democratic count. Meanwhile, Bob Dole became the first presidential candidate to win the male vote but lose the election.

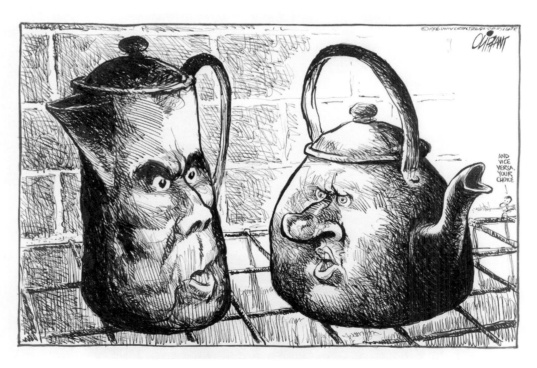

Presidential candidates, drawing by Pat Oliphant, 1996. As Election Day drew nearer, mud slinging rose between the two nominees, as evoked by the "pot calling the kettle black" reference in this cartoon.

1996
Republican Candidates

FOR VICE PRESIDENT JACK KEMP

VOTE REPUBLICAN IN 1996

FOR PRESIDENT BOB DOLE

2004

George W. Bush (Republican) v. John Kerry (Democrat)

"President Bush has not been honest with the American people, and certainly has failed in almost everything he professes to be doing in Iraq and Afghanistan, unfortunately."

—*Jimmy Carter*

Electoral Votes	Popular Votes
Bush 286	Bush 62,040,610
Kerry 251	Kerry 59,028,444

A wartime president can generally count on majority support from the voters in an election year, but 2004 was different. The terrorist attacks of September 11, 2001, had rallied nearly everyone behind President George W. Bush, and the subsequent invasion of Afghanistan to depose the Taliban for sheltering al-Qaeda mastermind Osama bin Laden was generally viewed with favor. But when the Bush administration began to beat the drums for overturning Saddam Hussein's regime in Iraq, claiming the dictator was developing or harboring weapons of mass destruction, public opinion began to fracture. By early 2004, the nation had seen the U.S. armed forces successfully complete major combat operations to bring down the Iraqi dictatorship, only to have that country descend into violent internal chaos, with insurgent factions waging bloody guerilla warfare upon American troops and the Iraqi people.

Democratic senator John Kerry of Massachusetts began to criticize the Bush administration for wildly underestimating the scale of postcombat operations and for misleading the country into accepting the reasons for the invasion in the first place. Kerry quickly became the frontrunner for the Democratic nomination after early primary triumphs over former Vermont governor Howard Dean, an outspoken war opponent who had captured both money and support with the first effective, large-scale use of Internet social networking for campaign purposes. After choosing North Carolina senator John Edwards as his running mate, Kerry embarked on a campaign to bring the Bush war record into high relief, claiming that the money and attention spent on a questionable invasion could have been directed to solving domestic problems. Kerry and Edwards promised Americans a fresh start, but Kerry's campaign was dogged by criticism of his own military service and missteps in charging that Bush shirked his duty in the Vietnam War by joining the Texas National Guard. A story on *60 Minutes* about Bush's military record turned out to be based on falsified documents supplied by a Democratic operative. Meanwhile, Kerry reacted slowly to accusations leveled in a series of widely viewed TV ads sponsored by a group calling itself Swift Boat Veterans for Truth. They claimed that his acts of valor in Vietnam had been exaggerated and that his subsequent criticism of the war, while testifying in congressional hearings as a young veteran in 1971, had undermined the efforts of his fellow soldiers.

As in 2000, Election Day 2004 came down to one state: this time, Ohio. And, once again, there were charges of voting irregularities. But the margins were nowhere near as close as they'd been in Florida in 2000. The results weren't certified until the day after the election, but there would be no month-long wrangling: Bush won the popular vote nationwide by more than 3 million.

Fighting for Affordable Healthcare, poster, 2004. John Kerry proposed a more comprehensive health-care package than George Bush did in the 2004 campaign, but voters were skeptical about how it would be funded.

georgewbushstore.com by Spalding Group